WEDDING PHOTOGRAPHY

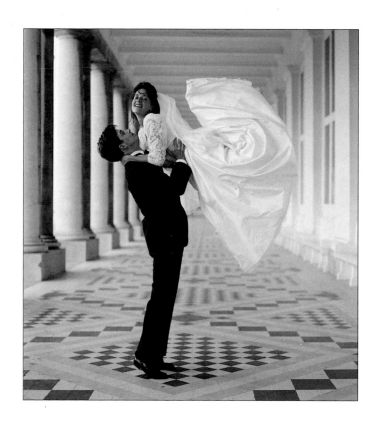

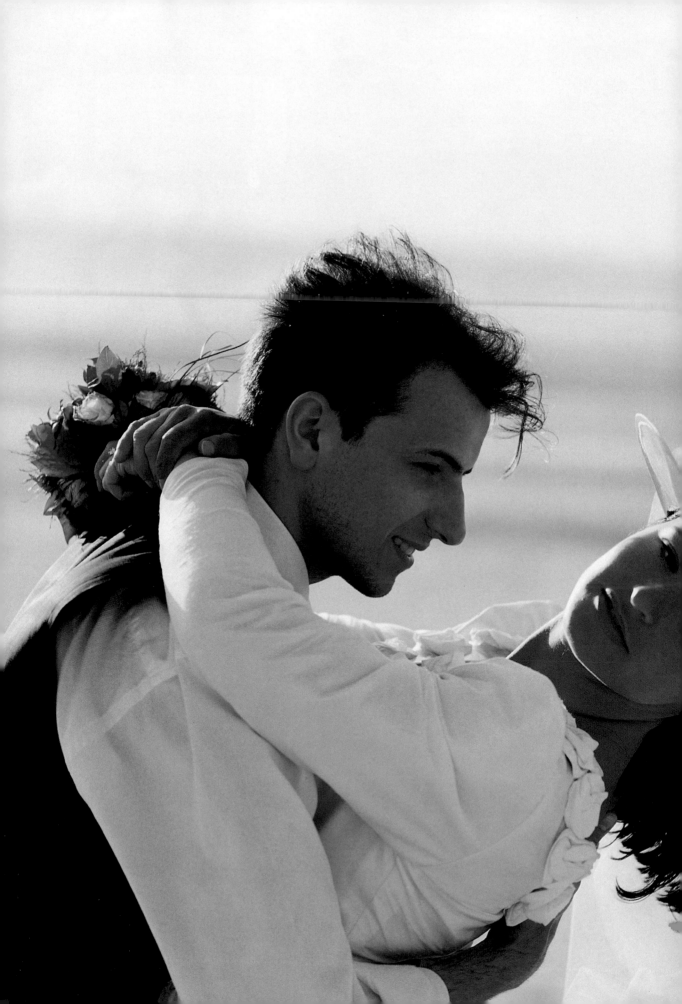

ROTOVISION
PRO-PHOTO SERIES

WEDDING PHOTOGRAPHY

JONATHAN HILTON

A Rotovision Book

Published and distributed by RotoVision SA
Rue Du Bugnon 5
1299 Crans-Pres-Celigny
Switzerland

RotoVision SA, Sales & Production Office
Sheridan House 112/116A Western Road
HOVE BN3 IDD. England
Tel: 44-1273-7272-68
Fax: 44-1273-7272-69

Distributed to the trade in the United States:
Watson-Guptill Publications
1515 Broadway
New York, NY 10036

ISBN 2-88046-253-3
2nd Reprint 1997

This book was designed, edited and produced by
Hilton & Kay
63 Greenham Road
London N10 1LN

Design by Phil Kay
Picture research by Anne-Marie Ehrlich

DTP in Great Britain by
Hilton & Kay
Printed in Singapore
Production and separation in Singapore by ProVision Pte Ltd
Tel: +65 334 7720
Fax: +65 334 7721

Photographic credits
Front cover: Nigel Harper
Page 1, 2-3: Van de Maele
Page 160: Philip D Durell
Back cover: Majken Kruse

CONTENTS

CHAPTER ONE WEDDING PREPARATIONS

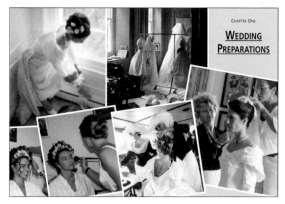

CHAPTER TWO LEADING PLAYERS

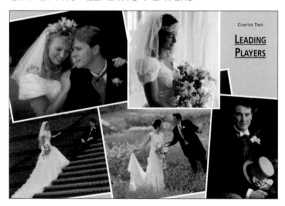

CHAPTER THREE SUPPORTING CAST

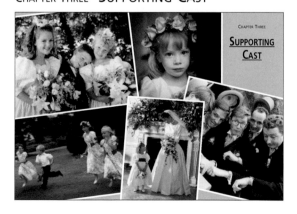

CONTENTS

CHAPTER FOUR **THE CEREMONY**

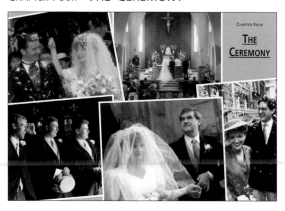

CHAPTER FIVE **THE RECEPTION**

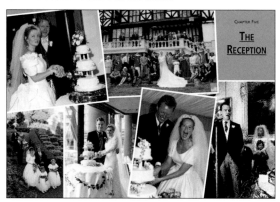

CHAPTER SIX **PORTFOLIOS**

INTRODUCTION

In the calendar of events of most families, a wedding ranks very near the top of the list in terms of its significance. To the parents of both the bride and groom, who these days often share the costs of the reception, the marriage of their children is also the motivation for the single most expensive celebration they ever hold. And in the weeks, months, and years following the marriage day, after all the tensions and anxieties are long forgotten, it is the portfolio of wedding photographs that will most vividly recall the excitement, happiness, and fun of the day.

The photographer's role

The professional wedding photographer has to strike a balance between putting the necessary time into each job, in order to find out exactly what the client wants, and yet not spend so much time that the agreed fee for producing the pictures becomes uneconomic.

At least one planning meeting with the couple is essential. At this meeting, it is important to discuss when the photographic coverage is to start – at the wedding venue, for example, or earlier at the bride's home on the day itself. Some couples may also ask for studio photographs to be taken before the wedding day, or location shots. If location shots are wanted, then you will have to agree where and when.

Make sure at this meeting that you also confirm the time and location of the wedding ceremony, and of the reception if you are covering that as well. Many photographers are asked just to shoot the ceremony and, say, one or two pictures of the couple cutting the cake. But even if this abbreviated coverage of the reception is all that is required, you will still have to budget for the time and expense involved in getting there.

It is also a good idea to agree beforehand a detailed shot-list of the "can't be missed" photographs, such as the set-piece shots of the bride arriving at the church, registry office, or wherever it is the ceremony is taking place, the couple taking their vows, signing the marriage register afterwards, family and friends throwing confetti, and so on.

The cost of the photography coverage is often determined by the number

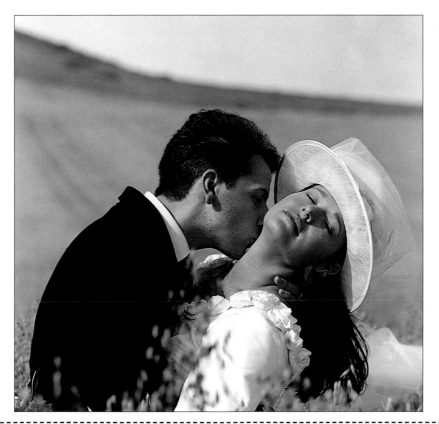

PHOTOGRAPHER:
Van de Maele

CAMERA:
6 x 6cm

LENS:
180mm

EXPOSURE:
$\frac{1}{250}$ second at f8

LIGHTING:
Daylight only

◀ *If the newlyweds have the time on their wedding day, and a suitable location is not too far away, then photographs such as this make a welcome change from the more formal type of coverage. More likely, however, is a photographic session a day or two before the ceremony.*

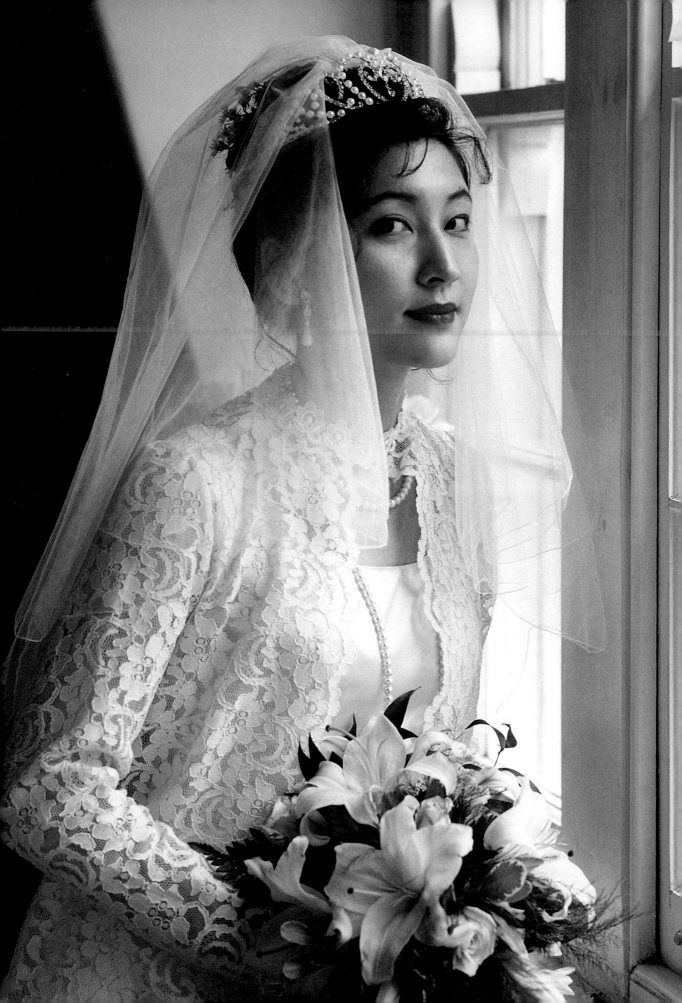

of pictures the clients wish you to produce for the finished portfolio – but if anything in the pre-wedding discussions leads you to believe that an additional fee will be likely, then agree this contingency in advance, and in writing.

Using this book

The chapters in this book are arranged in the approximate order of events on a typical wedding day, with extra chapters integrated into the sequence that look in more detail at different types of photographic approach. The first chapter deals with the preparations on the day of the wedding, and this is followed by a chapter that concentrates on the bride and groom – the leading players – photographed in the days before the actual wedding.

Next is a series of photographs featuring the supporting cast – best man, bridesmaids, page boy, and all those who play such vital roles on the wedding day.

The next two chapters deal with the actual ceremony, from the arrival of the bride at the church to the newlyweds leaving afterwards for the reception, and then the reception, with a range of different photographic approaches to the set-piece shots, such as cutting the cake, the speeches from the head table, and the bride and groom taking to the floor for the first dance.

Finally, the portfolios chapter takes a more detailed look at the work of three photographers and the way each one has tackled the wedding day celebration from beginning to end.

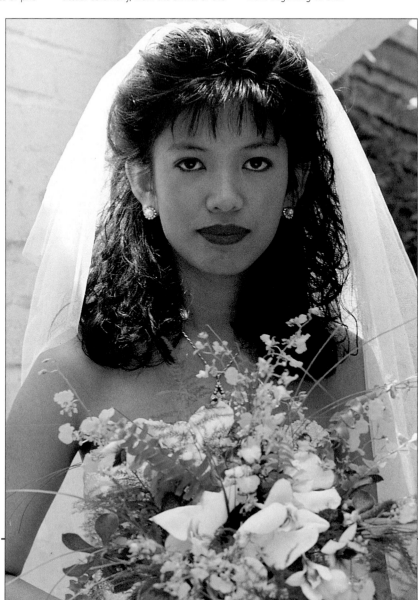

PHOTOGRAPHER:
Majken Kruse
CAMERA:
6 x 4.5cm
LENS:
70mm (left)
105mm (right)
EXPOSURE:
¹⁄₃₀ second at f8 (left)
¹⁄₁₂₅ second at f11 (right)
LIGHTING:
Daylight only (left)
Daylight and flash (right)

◀ *Natural daylight is often the most flattering for this type of wedding portraiture. Window light tends to be very contrasty, however, so make sure that you take your light reading from the most representative part of your subject.*

▶ *When you need to lighten shadows, or add some extra "sparkle" on an overcast day, mixing flash with daylight may be the best solution. Avoid direct flash, however, since results are rarely satisfactory.*

EQUIPMENT AND ACCESSORIES

As a wedding photographer you need to strike some sort of balance in terms of the equipment and accessories you take with you when fulfilling a commission. On the one hand, you don't want to miss out on good shots through not having, say, the right lens or filter readily available at some critical moment in the proceedings. Or you may suddenly find that your camera runs out of film just as the wedding vows are being exchanged, and your spare camera, preloaded with film, is safely locked in the boot of the car. On the other hand, you can't be so burdened with gear that your mobility is impaired – and you do often have to move quickly to get into position – or that you can't immediately lay hands on just the accessory you need because there is so much unnecessary clutter in your camera case.

POPULAR CAMERA FORMATS
The two most popular camera formats for wedding photographers are the 35mm format and the many variations of medium format cameras presently available. Both have certain advantages and disadvantages, and you will often find that photographers use both types, changing between them as the occasion demands.

Medium format cameras
Traditionally the camera type most often used by wedding photographers is the medium format rollfilm camera. This camera format, of which there are many variations, is based on 120 (for colour or black and white) or 220 (mainly black and white) rollfilm. Colour film has a thicker emulsion than black and white,

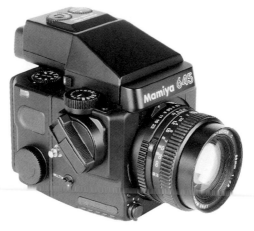

◀ The smallest of the medium format cameras, producing rectangular negatives or slides measuring 6cm by 4.5cm

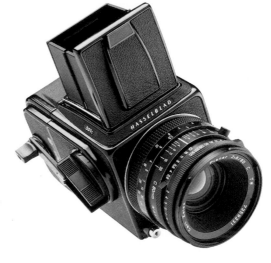

◀ This is probably the best known of all the medium format cameras, producing square-shaped negatives or slides measuring 6cm by 6cm.

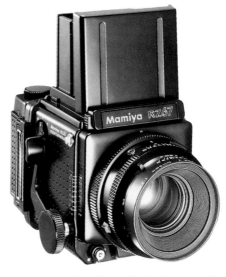

◀ This is the largest of the popular medium format cameras, producing rectangular negatives or slides measuring 6cm by 7cm. (A 6 x 9cm format is also available.)

and so 220 colour film is not generally available because it cannot physically be accommodated in the film chamber of the camera.

The three most popular sizes of medium format cameras are 6 x 4.5cm, 6 x 6cm, and 6 x 7cm models. The number of exposure per roll of film you can typically expect from these three cameras are:

Camera type	120 rollfilm	220 rollfilm
6 x 4.5cm	15	30
6 x 6cm	12	24
6 x 7cm	10	20

The advantage most photographers see in using medium format cameras is that the large negative size – in relation to the 35mm format – produces excellent-

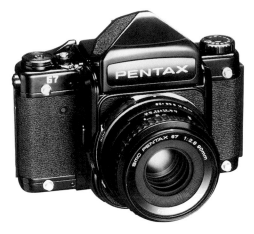

◄ This type of 6 x 7cm medium format camera looks like a scaled-up 35mm camera, and many photographers find the layout of its controls easier to use than the type opposite.

quality prints, especially when big enlargements are called for, and that this fact alone outweighs any other considerations. The major disadvantages with this format are that, again in relation to the 35mm format, the cameras are heavy and slightly awkward to use, they are not highly automated (although this can often be a distinct advantage), they are expensive to buy, and you get fewer exposures per roll of film (making more frequent film changes necessary).

35mm single lens reflex cameras (SLRs)

Over the last few years, the standard of the best-quality lenses produced for the 35mm SLR camera format has improved to the degree that for normal or average sized wedding enlargements – of, say, 20 x 25cm (8 x 10in) – results are superb.

The 35mm format is the best supported of all the formats, due largely to its popularity with amateur photographers. There are at least six major 35mm manufacturers, each making an extensive range of camera bodies, lenses, dedicated flash units, and specialized as well as more general accessories. Cameras within each range include fully manual and fully automatic models. Lenses and accessories made by independent companies are also available. Compared with medium format cameras, 35mm SLRs are lightweight, easy to use, generally feature a high

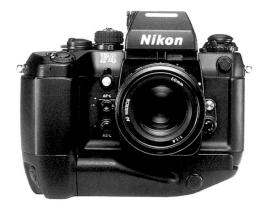

◄ This top-quality professional 35mm camera, here fitted with a motor drive, features a rugged die-cast body; a choice of three different metering systems; interchangeable viewing screens and finders; exposure lock and exposure compensation; and a choice of aperture- or shutter-priority, fully automatic, or fully manual exposure.

degree of automation, and are extremely flexible working tools. When bigger-than-normal enlargements are required, however, medium format camera have an edge in terms of picture quality.

All 35mm SLRs use the same film stock – cassettes of either 24 or 36 shots, in colour or black and white. Again because of this format's popularity, the range of films available is more extensive than for any other type of camera.

Useful accessories

When a high through-put of film is likely you can avoid having to change film at the end of each 24- or 36-exposure cassette by attaching a bulk-film back to the camera. This facility is offered only on professional-type system SLRs, but it gives you the option of loading up to 250 frames of continuous film.

Although many modern 35mm SLRs have built-in film advance and continuous shooting at rates of about three frames per second, some older models and professional-quality modern manual SLRs can be fitted with an accessory motor drive. This facility, whether built-in or added, automatically advances the film every time you press the shutter release or continues shooting for as long as you keep the shutter release depressed. Bear in mind, however, that a motor drive uses a lot of film very quickly, and the motor may also be noisy, which may make it unpopular inside the church or registry office during the actual wedding ceremony.

LENSES

When it comes to buying lenses you should not compromise on quality. No matter how good the camera body is, a poor-quality lens will take a poor-quality picture, and this will become all too apparent when enlargements are made. Always buy the very best you can afford.

One factor that adds to the cost of a lens is the widest maximum aperture it offers. Every time you change the aperture to the next smaller number – from f5.6 to f4, for example – you double the amount of light passing through the lens, which means you can shoot in progressively lower light levels without having to resort to flash. At very wide apertures, however, the lens needs a high degree of optical precision to produce distortion-free images. Thus, lenses offering a widest maximum aperture of f1.2 or f1.4 cost considerably more than lenses with a widest maximum aperture of f2 or f2.8.

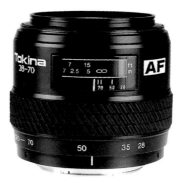

▲ A 28-70mm zoom lens made for the 35mm camera format.

35mm lenses

At a "typical" wedding you may need lenses ranging from wide-angle – for broad views showing the setting or the interior of the church or other building where the ceremony is taking place, or for large-group portraits – through to moderate telephoto – to allow you to bring up more distant detail to a large size in the viewfinder. For the 35mm format, the most useful lenses are a 28 or 35mm wide-angle, a 50mm standard lens, and about a 135mm to 200mm telephoto lens.

As an alternative, you should consider using a combination of different zoom lenses. For example, you could have a 28-70mm zoom and another covering the range 70-210mm. This way you have in just two lenses the extremes you are likely to use, plus all the intermediate settings you could possibly need to "fine-tune" subject framing and composition.

Medium format lenses

There are fewer focal lengths made for the medium format compared with 35mm, and lenses are larger, heavier, and more expensive. The same categories of medium format lens requirements apply – in other words,. wide-angle, standard, and moderate telephoto. There is also a limited range of medium format zoom lenses to choose from.

FLASH LIGHTING

The most convenient artificial light source for a wedding photographer working on location at a church or reception is undoubtedly flash. Different flash units produce a wide range of light outputs, so make sure you have with you the one that is most suitable for the type of area you need to illuminate.

Tilt-and-swivel flash heads give you the option of bouncing light off any convenient wall or ceiling, so that your subject is illuminated by reflected light. This produces a kinder, more flattering effect, although some of the power of the flash will be dissipated.

The spread of light leaving the flash head is not the same for all flash units. Most are suitable for the angle of view of moderate wide-angle, normal, and moderate telephoto lenses. However, if you are using a lens with a more extreme focal length you may find the light coverage inadequate. Some flash units can be adjusted to suit the angle of view of a range of focal lengths, or adaptors can be fitted to alter the spread of light.

◀ *This style of flash fits into the camera's "hot shoe" on top of the pentaprism, where electrical contacts trigger it to fire when the shutter is operated. This model emits a special beam of light to help the camera's autofocus system to find and lock on to the subject, even in the dark.*

▼ *This "candlestick" style of flash attaches to the tripod mount on the camera's baseplate. The head tilts and swivels and its off-centre position gives a slightly directional lighting effect.*

▲ *Direct flash produces the least flattering of all the lighting effects. The surfaces of the subject are either lit or unlit and shadows are hard-edged.*

▲ *By diffusing the flash with, say, a layer or two of a white handkerchief, the light effect becomes softer, and shadows less well defined.*

▲ *Moving the flash off-centre, to the left or right of the camera position, you start to emphasize subject texture, but shadows are, once more, hard-edged.*

▲ *Bouncing the light from a wall or ceiling produces near shadowless lighting. Use a neutral-coloured surface to avoid unwanted colour casts.*

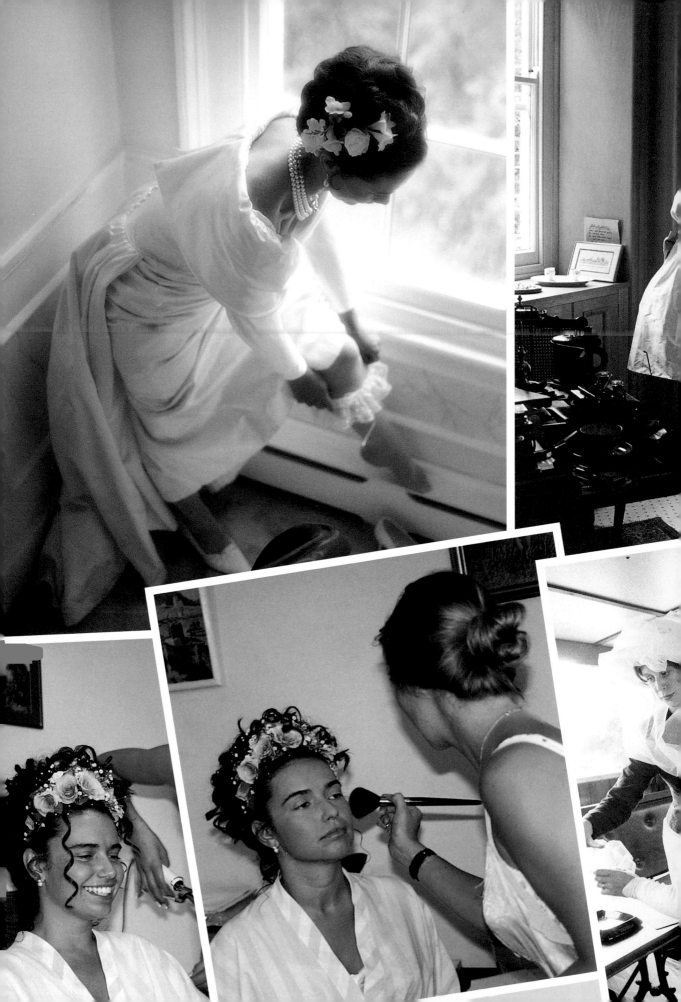

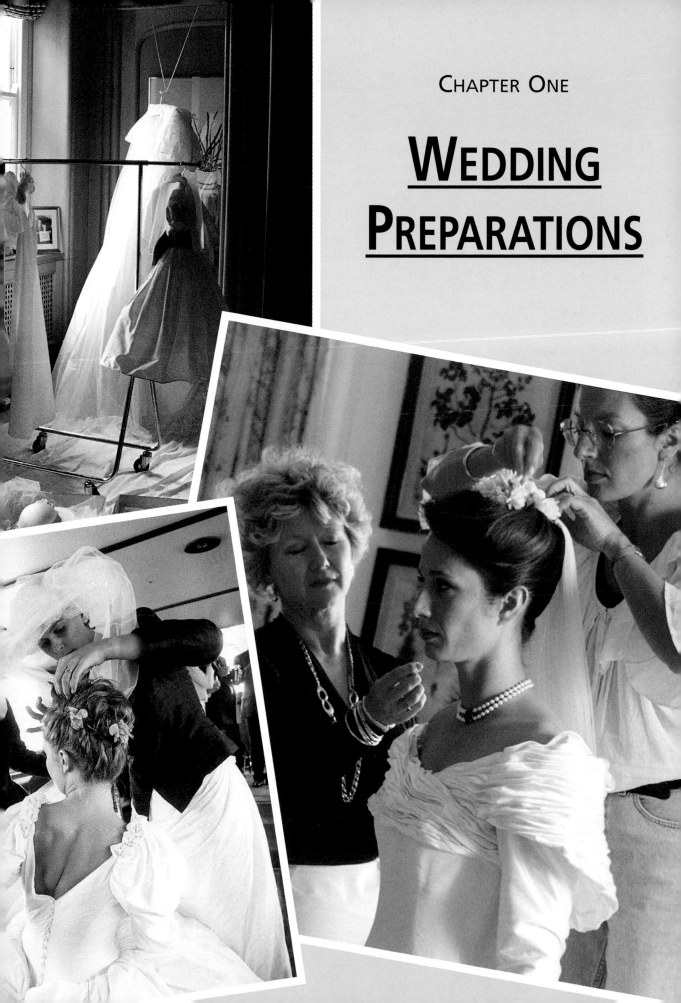

WEDDING PREPARATIONS

A COMPLETE MAKE-OVER

Preparations for the bride on the day of the wedding itself must start many hours in advance of the actual ceremony. You can imagine, however, that the last thing anybody wants is somebody in the house with a camera and lights getting in the way when there is so much to do – and when nerves are perhaps getting a little frayed. You, therefore, need to explain to clients that, in the long term, they will probably be happier with their wedding portfolio if they have a record of at least some of those manic, behind-the-scenes preparations.

If it is a sunny day and the house you are photographing in is bright with lots of windows, you may be tempted to rely on natural light. Often, this is a mistake. Window light is almost always too contrasty for the type of detailed shots required, and if your subject happens to be shown against a window then the camera's light meter will almost certainly set an exposure that renders the subject as a silhouette. It is a better idea to rely instead on flash for the main illumination and use any available daylight as fill-in light.

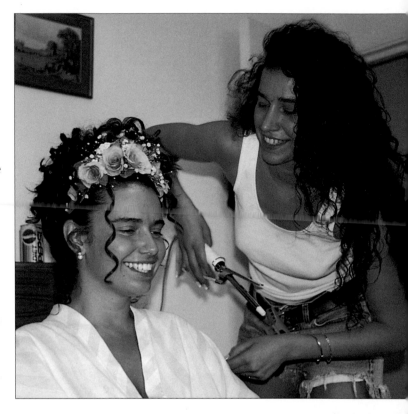

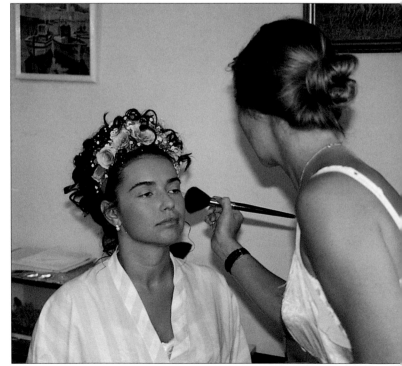

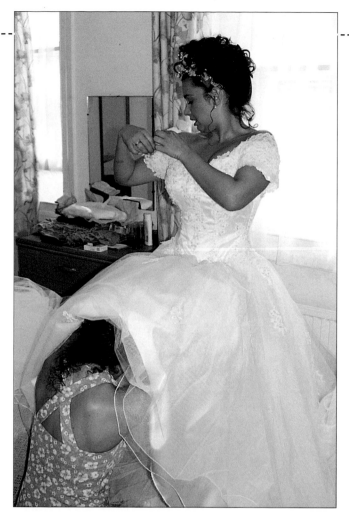

◀ The first stage of preparing the bride for the big day is styling her hair. If the style involves an elaborate flower headdress, as here, you should have at least an hour or more in which to take your shots. Once the bride's hair has been styled, the next stage is to apply her make-up (see below left). On an occasion like this, a professional make-up artist is likely to be used to ensure that the bride looks flawless. Make-up should take between 20 and 35 minutes.

▶ Always keep your wits about you, since you never know when a good picture opportunity is going to arise. This amusing candid shot occurred when the bride's helper suddenly plunged underneath the bridal gown to sort out a problem with one of the underskirts.

Applying make-up

The aim of applying make-up is to accentuate the subject's best facial features while minimizing any irregularities or blemishes. The first step is to use a moisturizer to improve skin quality. This is then followed by a foundation product, concealer (if needed), and a dusting of translucent powder. With the broad areas of the face made up, you next concentrate on the details. Starting with the eyes, paint fine lines around the upper and lower lids, followed by eye shadow. Next, define the brows using an eyebrow pencil and then apply mascara to both the top and bottom eyelashes. To bring out the bone structure around the cheeks, blusher can be applied with a large, soft brush. The final stage is the lips. Here, you can first outline the shape of the lips with a pencil or brush, using a shade slightly darker than that used on the lips themselves. For better control, use a brush to apply the lipstick colour, and, finally, an application of lip gloss.

◀ This picture was taken just before setting off for the ceremony. Everybody wanted a bit of fun to let off steam and calm any jangling nerves.

Equipment checklist

● **35mm SLR camera** When conditions are cramped and the action is moving too fast for a tripod to be used, a lightweight 35mm SLR, which can be easily hand held, has distinct advantages over medium-format cameras.

● **Power winder** Many modern 35mm SLRs have built-in autowinders or power winders to advance the film after each exposure. If not, use a camera that allows you to add one as an accessory.

● **Flash** Even if your camera has a built-in flash, it is still better to use an add-on model to avoid the potential problem of "red-eye". Use a flash model with a swivel and tilt head to allow you to bounce light off the walls or ceiling.

● **Film and batteries** Always have more spare film and extra batteries for both the camera and flash than you think you will need.

PHOTOGRAPHER:
Majken Kruse

CAMERA:
6 x 6cm

LENS:
120mm

EXPOSURE:
⅟₆₀ second at f16

LIGHTING:
**Daylight and heavily
diffused flash**

▶ *Arriving at the church looking confident and happy – hair, make-up, and gown all looking perfect for the camera.*

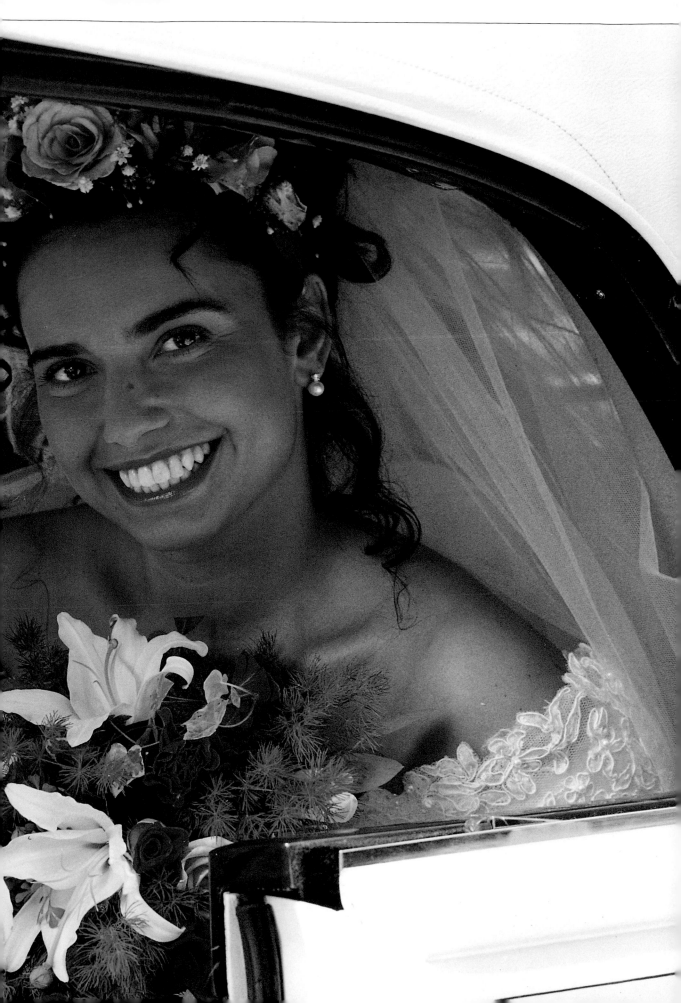

Last-minute adjustments

Many wedding albums only start with the groom and guests outside the church, registry office, or other building where the marriage is to take place, waiting for the bride to arrive. As you can see here, this is a great pity, since many informal yet memorable photographic opportunities may well be missed.

The hour or two before the bride leaves home for the ceremony can often be tense and full of activity. At this time, you will not be popular if you get in the way or ask people to stop what they are doing and pose for you.

You therefore have to work quickly, quietly, and professionally, seizing your opportunities as and when they arise for more candid coverage.

TTL (through-the-lens) camera metering systems are a great boon, but many of these do not perform reliably well when there is a wide exposure difference between the shadow areas and the highlights contained in the same scene. Knowing this, the photographer has to make the decision about which part of the picture to expose for. In such a situation, it may be wise to use a hand-held exposure meter.

PHOTOGRAPHER:
Trevor Godfree

CAMERA:
35mm

LENS:
80mm

EXPOSURE:
$\frac{1}{125}$ second at f4

LIGHTING:
Daylight only

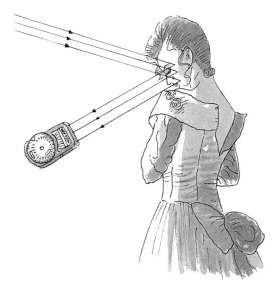

▲ *The contrast levels in the bedroom where the bride was dressing were very wide, and this is the type of situation where you might want to use a hand-held meter to ensure that exposure is spot-on. For the* *photograph illustrated here, the photographer determined that the skin tones of the bride's face were the most important part of the frame, and so the light reading was taken from there.*

▶ *Exposure was difficult in this situation because of the range of contrasts within the scene. It was important to ensure that not only the bride's face was well exposed, but also that just enough detail could be seen in the helper's face to stop it completely disappearing in shadow.*

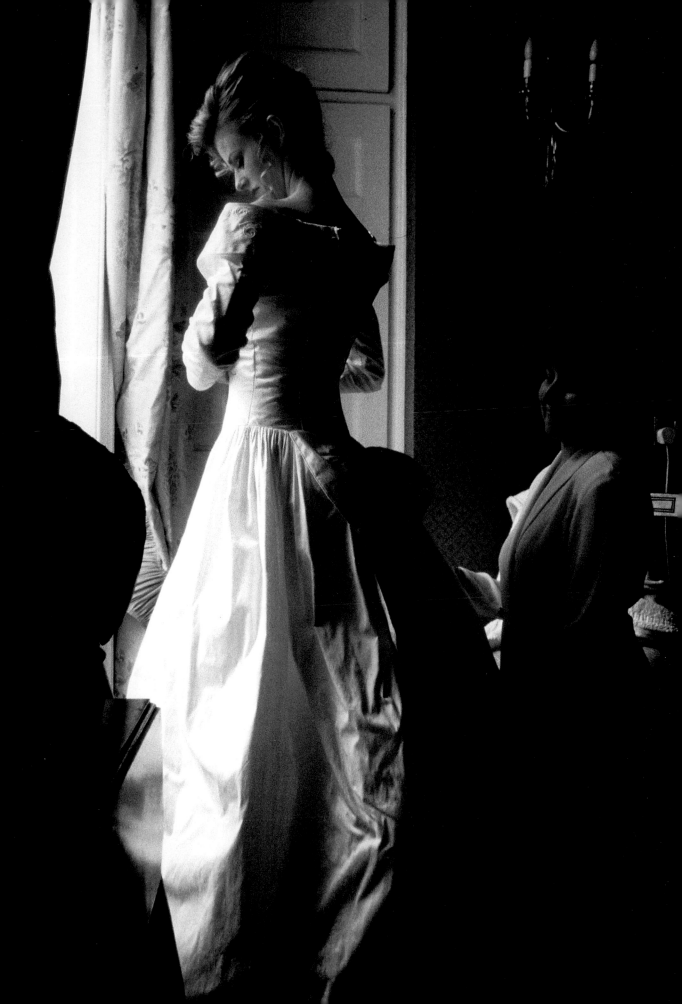

FILLING THE FRAME

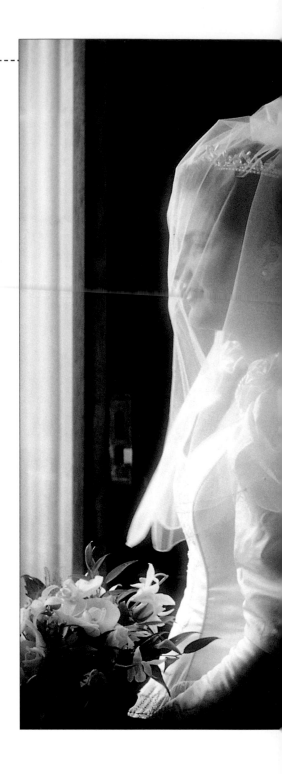

All of the supporting cast of players on the bride's side can be seen in this wedding album photograph. The bride's mother is on the far side of the group, made up of the bridesmaids and the young ring bearer, who is holding the cushion on which the rings will be placed during the ceremony. This group has been purposely rendered just slightly out of focus by the photographer's choice of a large aperture, which was also necessary because the only illumination for this shot was natural daylight entering the room through the window. The bride is the only sharply rendered element in the picture. This helps to imply that although she is part of the proceedings and the activity, she is also feeling slightly apart from it – an aloofness that is reinforced by her veil being down. Perhaps she is taking this last opportunity to calm her nerves before leaving for the ceremony.

PHOTOGRAPHER:
Richard Wilkinson

CAMERA:
35mm

LENS:
70mm

EXPOSURE:
⅟₆₀ second at f4

LIGHTING:
Daylight only

Hints and tips

● Most autofocus camera lock onto anything in the target area, usually found in the centre of the frame. In the picture here, this would have rendered the background group sharp and the bride slightly out of focus.

● To overcome this problem, frame the shot with the bride in the centre of the frame, wait for the lens to focus, and lock the focus setting into the camera.

● Then, recompose the shot with the bride off to one side of the frame, with the original focus setting still locked into the camera.

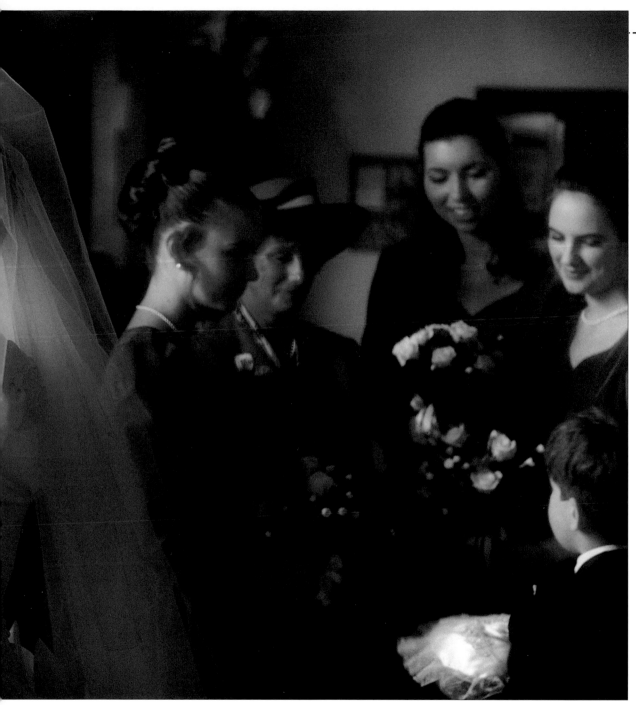

▲ To achieve this effect, the photographer selectively focused on the bride to ensure that she appeared sharp, and then chose an aperture that rendered the others in the room behind slightly soft. The difference between the clarity of the two main elements in the picture helps to establish depth and distance, as does the contrast between the bright white of the bridal gown and the deep purple of the bridesmaids' dresses.

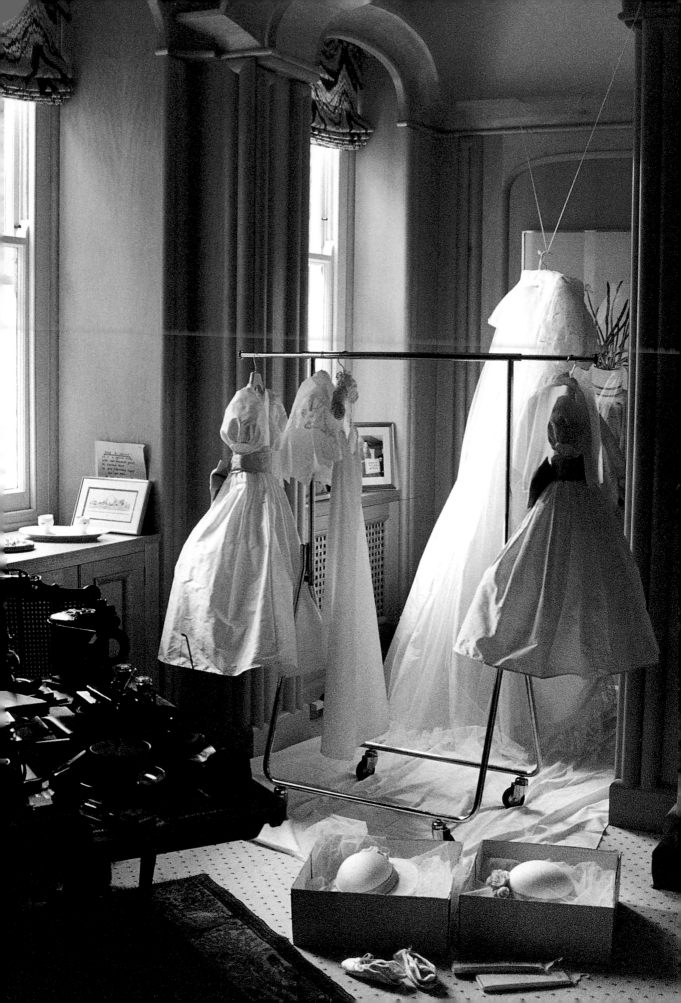

TEMPORARY LULL

Wedding pictures don't always have to feature people or be of the wedding or reception venue itself. Weddings, of any culture, are full of symbolism – details that are peculiar to that particular event, such as colours, flowers, accessories, and clothes. And it is clothes that have become the subjects of the still-life studies below and opposite.

Part of the magic of photography is that it captures a frozen instant in time. It doesn't matter that just seconds before the picture of the dresses hanging up was taken the room was full of people and activity, and that seconds afterwards the perfect calm of the scene was shattered once again as people flooded back in. As it is, the lighting, repetition of shapes and colours, the contrasts between highlight and shadow all combine to create a composition that invites you to explore the frame in minute detail.

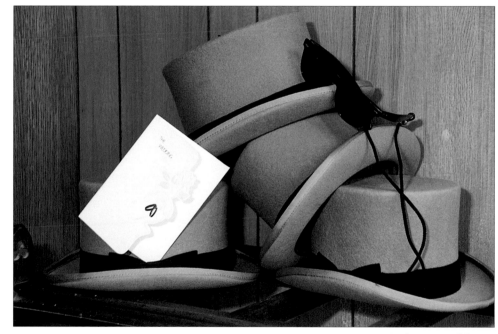

PHOTOGRAPHER:
Majken Kruse

CAMERA:
35mm

LENS:
50mm

EXPOSURE:
¹⁄₁₂₅ second at f11

LIGHTING:
Daylight only

◀ The foreground silk shoes and hat boxes seem to act as stepping stones, taking the viewer's eye into the frame and toward the bridesmaids' dresses hanging in the middle ground and the bridal gown suspended at the rear. Exposure was calculated for the highlight side of the white clothing, which produced a shutter speed/aperture combination that lessened the visual impact of the table on the left of the picture without robbing it of all its interesting detail.

PHOTOGRAPHER:
Peter Trenchard

CAMERA:
35mm

LENS:
90mm

EXPOSURE:
¹⁄₆₀ second at f8

LIGHTING:
Bounced flash

▲ Top hats are one of the symbols of a formal Western-style wedding, and the invitation casually propped up against them makes the perfect finishing touch for the shot.

THE CAMERA DOESN'T LIE?

Depending on the camera angle and lens focal length you choose, the same scene may be interpreted in many different ways.

Although the pressure is always on the photographer to work quickly and efficiently, take a second or two to think before exposing the film and decide whether or not the elements in the viewfinder are telling the best story. Only when you are happy with what you can see, press the shutter release.

Two technical innovations on the photographer's side are the zoom lens, which allows you to fine tune framing, and automatic film advance, so you don't have to take your eye from the viewfinder to wind on.

PHOTOGRAPHER:
Majken Kruse

CAMERA:
35mm

LENS:
28-70mm zoom

EXPOSURE:
⅟₆₀ second at f8

LIGHTING:
Daylight only

▶ *Taken from a different camera position and with the lens zoomed back to a slightly wide-angle setting, this version of the scene tells a very different story to the other below. Now we can see that what appeared to be all calm and order was, in fact, a cauldron of activity, with a line of seated bridesmaids all waiting their turn to have their hair attended to.*

PHOTOGRAPHER:
Majken Kruse

CAMERA:
35mm

LENS:
28-70mm zoom

EXPOSURE:
⅟₁₂₅ second at f8

LIGHTING:
Daylight only

▲ *Taken at the telephoto end of a 28-70mm zoom lens, this version of the situation, taken just a little while before setting off for the wedding ceremony, shows a scene of calm and orderly concentration. The bride is having the finishing touches applied to her hair while her mother stands by proudly admiring the results, and offering a few suggestions.*

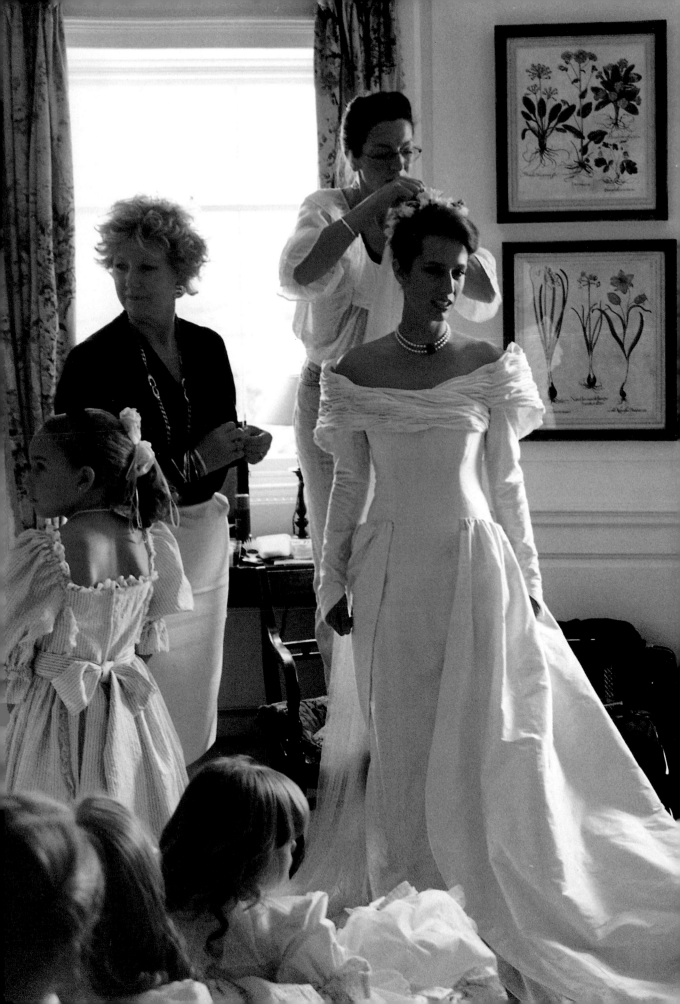

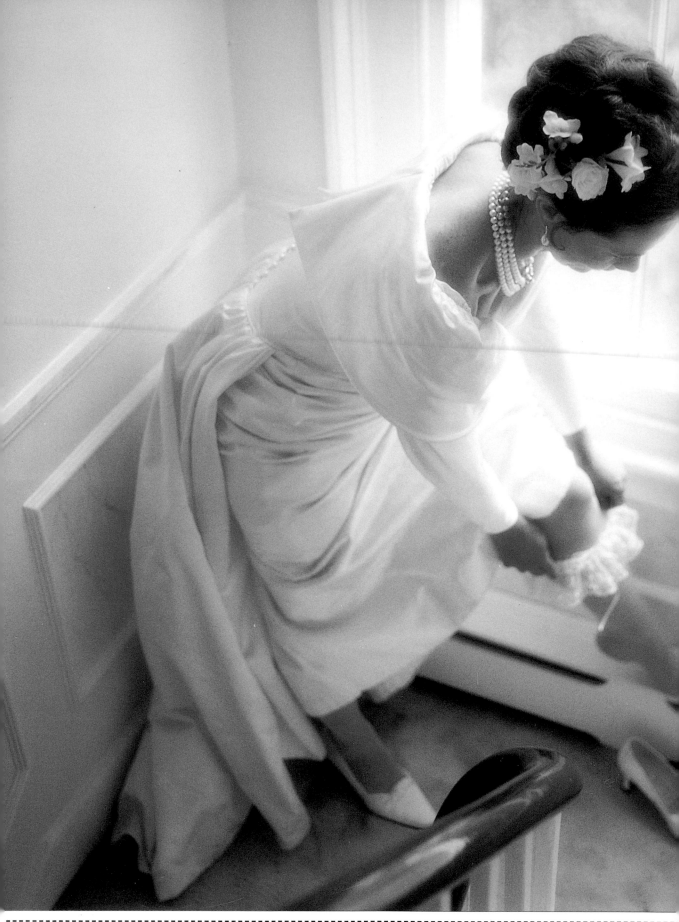

THE UNOBSERVED CAMERA

The appeal of some photographs has as much to do with the fact that they appear to have been taken without the subject's knowledge as they do with the actual content. The photograph here is such an example, showing the bride, on her way down the stairs to leave the house for the wedding ceremony, pausing briefly to slip a garter onto her leg – a personal act that the camera would not normally be there to record.

Time was critically short at this point in the proceedings, and the photographer had no time to set up a flash, and thus had to rely solely on whatever daylight was entering through the side window. As a result, a slow shutter speed and a large lens aperture had to be used, and the zone of sharp focus – the depth of field – was not extensive enough to encompass the whole figure. Instinctively, however, in the split second that was available for the shot, the photographer made the correct decision and focused on the bride's face. In almost all circumstances, the most crucial part of any portrait is the face – especially the eyes – which is something to bear in mind whenever you are in doubt about what to focus on if depth of field is restricted.

PHOTOGRAPHER:
Desi Fontaine

CAMERA:
6 x 6cm

LENS:
120mm

EXPOSURE:
⅟₃₀ second at f4

LIGHTING:
Daylight only

◄ *Light levels were not high in this stairway, and the photographer was forced to use what daylight was available. The wide aperture used on a moderate telephoto lens resulted in a restricted depth of field.*

SHOOTING IN BLACK AND WHITE

There is a fine line in commercial wedding photography between shooting only as much film as you need to in order to keep costs under control and ensuring that you take enough pictures to put together a top-class wedding portfolio. If the clients are agreeable, and indeed some clients even insist on it, one way of keeping costs down is to shoot all, or part, of the wedding in black and white. This film stock is less expensive than colour material, processing is quicker and cheaper, and the costs of prints offer a considerable saving. Clients may, for example, be quite happy to have a set of black and white prints covering the preparations before leaving the house and the reception, yet want a set of colour prints of the wedding ceremony part of the day.

Many people view black and white photography as being more of an art medium than colour. Once colour is removed from the calculation, the image is immediately simplified and, to a degree, abstracted. The two-dimensional photograph is already an abstraction of the three-dimensional world around us, but once colour is removed the process is taken much further. Photographers who specialize in black and white work often state that they prefer the freedom they have to interpret scenes and activities, rather than just making a life-like record of them.

PHOTOGRAPHER:
Nigel Harper

CAMERA:
35mm

LENS:
35mm

EXPOSURE:
$\frac{1}{125}$ second at f8

LIGHTING:
Daylight only

Hints and tips

● Black and white film costs, processing, and printing are all cheaper than in colour, so it is possible to shoot more images and produce a larger portfolio for the same cost.

● A wide range of lens filters can be used with black and white film to alter the tonal balance of the image.

● Black and white film has a very wide exposure latitude and is very forgiving of exposure errors.

● Black and white prints can be toned and tinted, overall or just locally, or printed on coloured paper, to produce a wide range of colour effects.

▶ The emphasis of the image alters considerably when you remove colour, with shape, form, texture, and contrast becoming more significant factors. In this picture, note how important the tonal contrasts are between the bridesmaids' skirts and their jackets, the skin texture of the bride's back and the shapes created by her muscles and bones as she twists her body. The shapes made by the bridesmaids' hands, too, are fascinating – one manipulating the bride's hair and the other poised over the bride's outstretched arm.

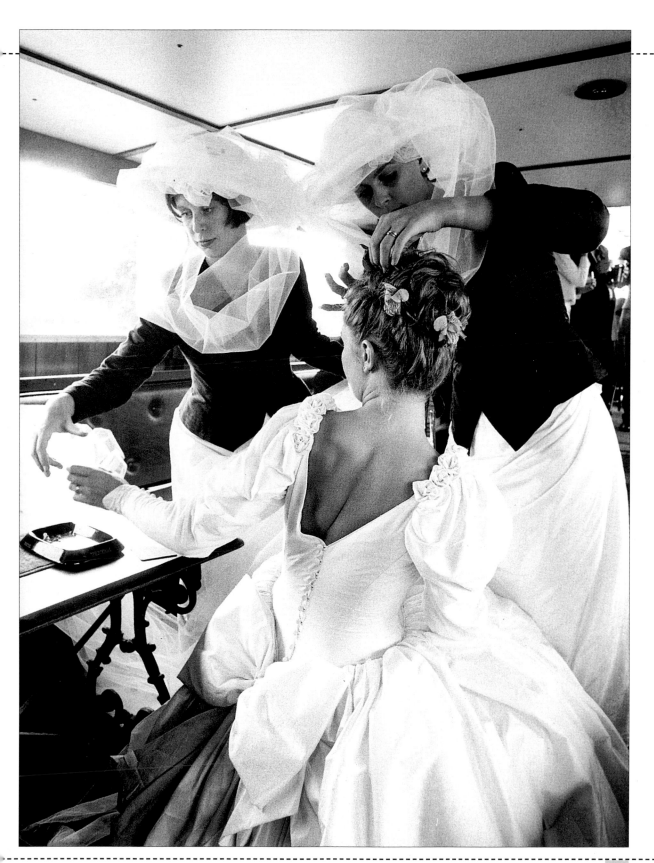

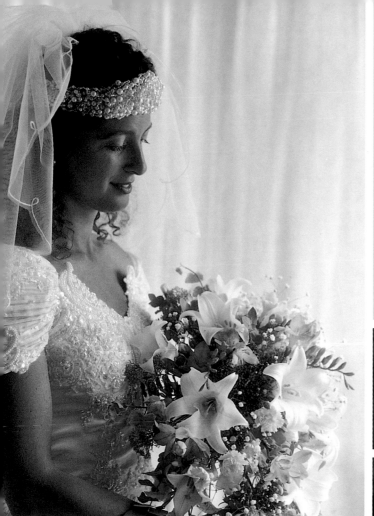

LEADING
PLAYERS

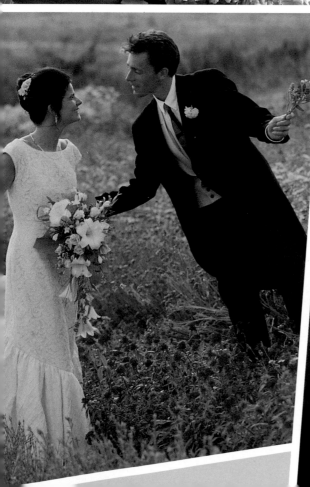

INDOORS OR OUTDOORS

Getting the wedding couple alone for a photographic session either before the wedding or at some stage on the wedding day – most likely at the reception – is often difficult. There will obviously be many demands on the time of the bride and groom and, being strictly practical, you will want to work as quickly and efficiently as possible within the fixed budget that has been agreed before the wedding. The quotation you give regarding costs will probably form part of a contract between both parties.

Take a few minutes before the couple are ready for you to have a quick scout around the venue chosen for the session to discover where its strong points lie. If the weather seems promising, look around the gardens or grounds and try to find a good combination of strong architectural and attractive garden features that you can take advantage of. If, however, the weather is not looking good, you may still be able to utilize a covered area adjacent to the building. Again, look for strong, uncluttered architectural features that would be worthwhile including in the photographs.

In order to achieve a good mix of shots, with plenty of changes of mood and pace, you will also hope to take some indoor portraits. On this point, much depends on what the venue has to offer, and how much lighting equipment you have available. If you are shooting the pictures on the day of the wedding, then try to incorporate at least some of the wedding decorations, floral displays, ribbons, and similar items. A lot of trouble goes into these aspects of the wedding so you should make the most of what has been provided. Bear in mind that it is exactly this type of detail that is important to the newlyweds and their families, and it is they who will be ordering the reprints from you.

PHOTOGRAPHER:
Desi Fontaine

CAMERA:
6 x 6cm

LENS:
75mm

EXPOSURE:
¹⁄₂₅ second at f8

LIGHTING:
Daylight supplemented by bounced flash and reflectors

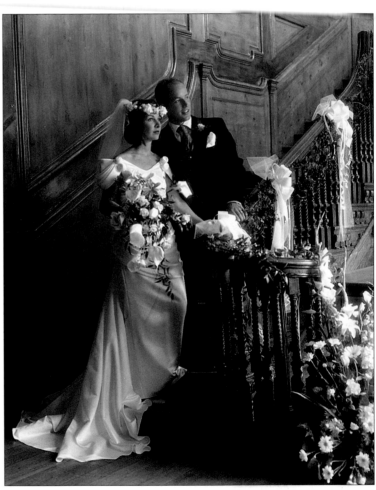

▲ *The rich wood panelling, handrail, and balusters, plus the floral decorations from the couple's reception, proved to be an irresistible combination for this wedding day portrait.* *Although there was quite a lot of natural illumination available from large windows opposite, light levels had to be boosted with some bounced flash and reflectors.*

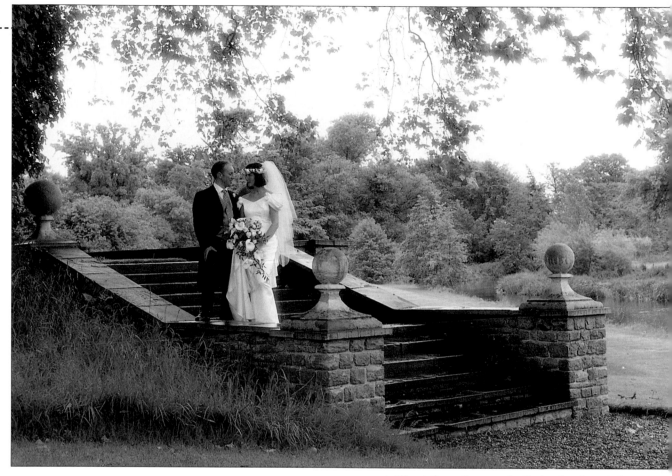

▲ When you are combining flash and daylight, be careful to avoid producing two set of conflicting shadows. To avoid this, align the flash light with the daylight, as you can see here. Light from the reflectors is not strong enough to cast shadows; it is used to lighten, just fractionally, the area around the bottom of the bride's gown.

▲ Although the weather was overcast and there had already been some rain that day, the sky was still bright and there proved to be plenty of daylight to work with. These broad stone steps, which led down through the grounds of the reception venue toward the river, proved to be an ideal location for a formal portrait of the newlyweds. The overhanging foliage in the foreground not only makes a romantic frame for the composition, it also helps to draw the viewer's attention away from what would have been a large expanse of unattractive and featureless grey sky.

EXPOSURE:
¹⁄₃₀ **second at f22**

LIGHTING:
Daylight only

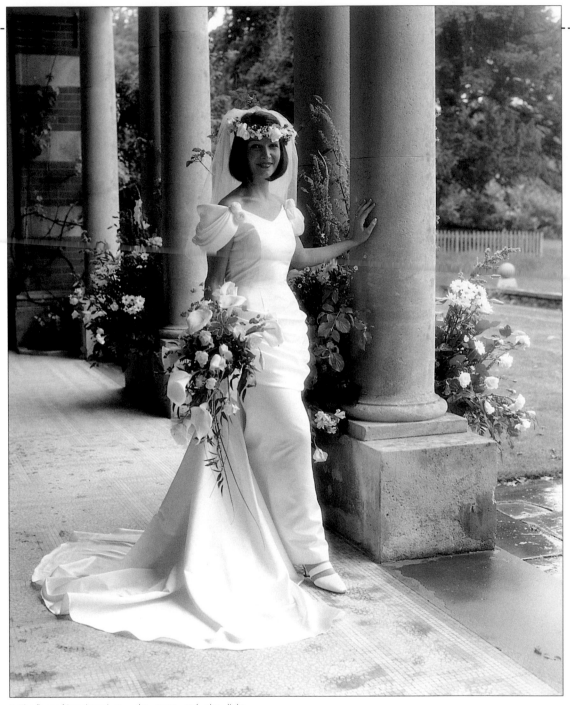

▲ *The flower-fringed porch at the side of the reception venue was surprisingly bright considering the weather. The rain-soaked step leading onto* *the grass and the light-coloured tiled floor inside both helped bounce a little extra light into the area selected for this portrait of the bride.*

EXPOSURE:
⅙₀ **second at f11**

LIGHTING:
Daylight only

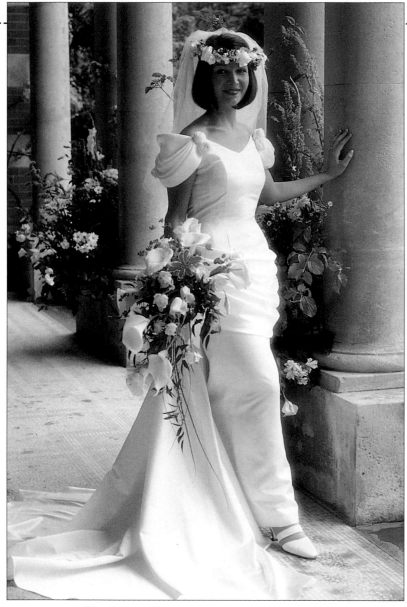

◄ It is better if you can make all cropping decisions before taking the picture so that each negative can be printed full frame. Sometimes, however, this is not possible, and even if it were, there is often more than one way of showing the same scene. In this version, which has been cropped from the full-frame image opposite, the view of the garden has been removed, as has much of the window in the rear wall. It is not necessarily any better or worse than the original framing, but it does have an entirely different atmosphere.

◄ Make two L-shaped card-board shapes like those shown here. You can then position them over any print leaving the area in the middle isolated from its surroundings. This will help you judge the merits of a particular crop before going to the time and expense of having it printed.

LOOKING RELAXED

When you are dealing with people who are not used to being in front of the camera – as will be the case with most wedding couples – there is always a tendency for them to go "wooden" on you. Part of your job is to make them unwind and relax, both before and during the photo session, by talking and joking with them, for example, or by getting them to talk to you about their interests, their plans for the wedding and what they will be doing afterwards, the house or apartment they will be moving to, their jobs, and so on. The quicker you can build up a friendly rapport with your subjects, the better the photographs are likely to be.

Even after you have overcome most the subjects' nerves and they are moving and holding themselves in a more relaxed manner, any vestiges of nervousness they may still have tend to show themselves in their hand and feet. Feet, for example, can take on a life of their own, sticking out at awkward angles, and hands can form into fists or be held with the fingers rigidly straight. Watch out for these sorts of details – it is very easy to overlook them when taking the pictures, but they will scream out of the photographs at you when it is too late to do anything about it.

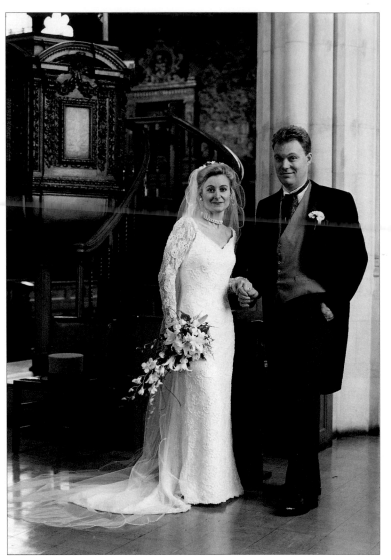

▲ *Here the photographer has coached the subjects to get them to look less wooden. The church setting and the pulpit behind are attractive features and their joined hands, although a little tense-looking, is a natural gesture. The bride's other hand is taken care of by the bouquet and the groom's has been kept out of sight in his pocket. The bride's gown hides her feet, and the groom's legs and feet look relaxed.*

PHOTOGRAPHER:
Hugh Nicholas

CAMERA:
6 x 7cm

LENS:
70mm

EXPOSURE:
1⁄60 second at f8

LIGHTING:
Flash supplemented by daylight

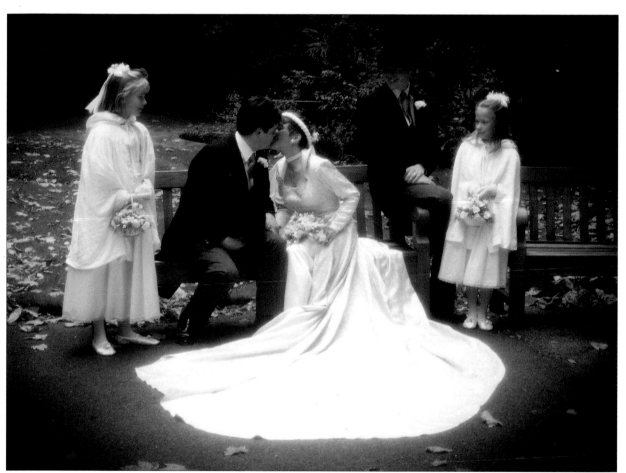

▲ This picture contains many elements that could spoil the shot if they don't look right. Note that both bridesmaids' hands have been positioned holding their floral baskets, while those of the best man are naturally at ease. One of the groom's hands is occupied with his hat, while his other hand is holding that of his bride's.

PHOTOGRAPHER:
Hugh Nicholas

CAMERA:
6 x 7cm

LENS:
70mm

EXPOSURE:
⅟₁₂₅ second at f11

LIGHTING:
**Daylight supplemented
by flash**

Hints and tips

● The more friendly and outgoing you can be with your clients, the more relaxed they are likely to look in the resulting photographs.

● Talk to your subjects about their interests and try to get them to respond to your questions. Once they start talking and asking you questions, the more animated and natural they will look in their pictures.

● If your subjects' hands look awkward, suggest that they use a prop – such as holding a hat, gloves, flowers, their partner's hand, and so on – to make them feel more comfortable.

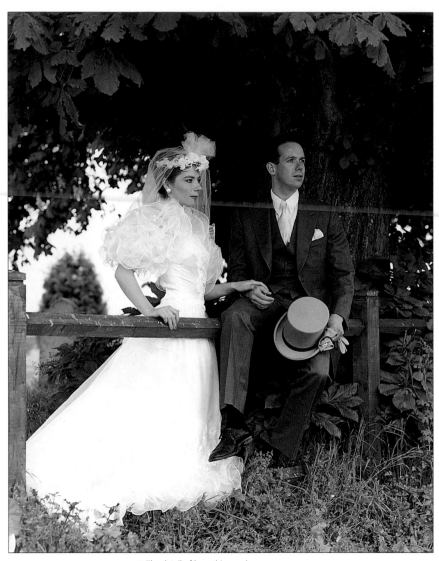

▶ The bride and groom look relaxed and happy in this garden setting. The bride's hands are out of sight behind the bouquet and the groom's visible hand is occupied with holding his hat and gloves.

▲ The detail of how this couple hold themselves has been well thought through. The wooden rail on which the groom is perched forces his legs and feet into a natural-looking position, and while one hand holds his hat and gloves the other is supporting his bride's hand. Her free hand is at ease, resting on the rail.

PHOTOGRAPHER:
Hugh Nicholas

CAMERA:
6 x 7cm

LENS:
120mm

EXPOSURE:
½₂₅₀ second at f5.6

LIGHTING:
Daylight supplemented by flash

PHOTOGRAPHER:
Mandi Robson

CAMERA:
6 x 6cm

LENS:
80mm

EXPOSURE:
½₆₀ second at f11

LIGHTING:
Daylight supplemented by flash

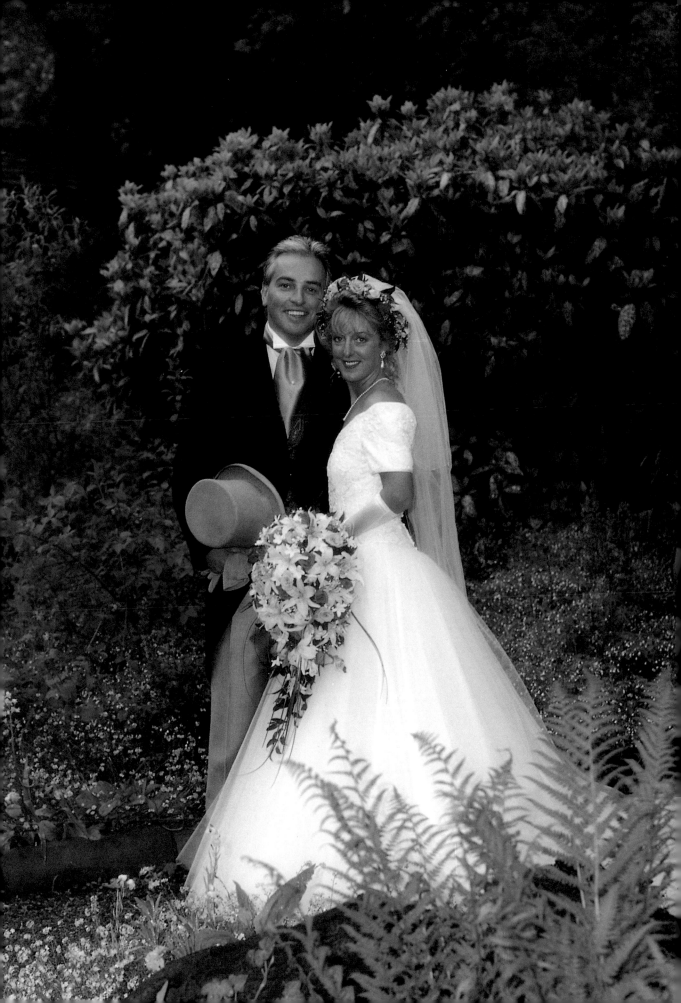

WITH OR AGAINST THE LIGHT ...

The usual advice given to photographers working in natural daylight – or indoors using studio lights – is that they should position themselves so that the sun (or studio light) is at their back and, thus, shining directly onto the subject. This is known as shooting with the light, or frontlighting. Indeed, so commonly is this advice adhered to that the majority of camera autoexposure systems are calibrated to give their most consistently accurate readings only in this general type of lighting situation.

▼ *With the sun shining onto the side of the subjects facing the camera, the resulting frontlit image is richly detailed. The surface qualities of the bride's dress and the groom's suit are well recorded and colours are bright and intense.*

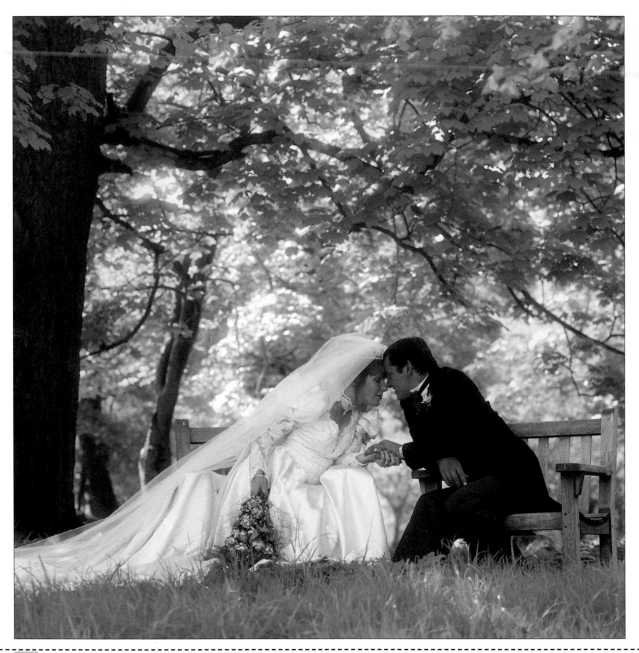

PHOTOGRAPHER:
Desi Fontaine

CAMERA:
6 x 6cm

LENS:
75mm

EXPOSURE:
1/500 second at f8

LIGHTING:
Daylight only

▼ *Taken from the other side of the couple, this picture records the shadow side of the subjects facing the camera. Because a shadow light reading was taken in order to produce this backlit exposure, the brightly lit scene beyond the subjects is massively over-exposed, creating a romantic type of effect in a landscape that seems to shimmer with an* intense heat. *The exposure difference between the subjects and the landscape also helps to isolate them from the setting, creating a strongly three-dimensional effect. Colours, too, are more subdued than in the frontlit version opposite – an effect that can sometimes be extremely useful when a more monochromatic type of image is required.*

EXPOSURE:
1/60 second at f8

LIGHTING:
Daylight only

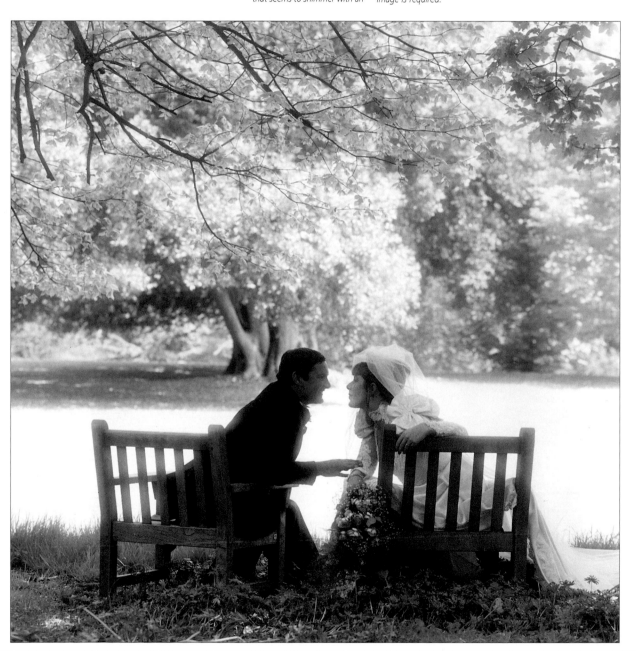

At the other lighting extreme you have what is known as shooting against the light, or backlighting. In this situation, the sun is at the subject's back, shining toward the camera, and so the side of the subject facing the photographer is effectively in shadow.

In most situations, frontlighting produces images that are richer in detail than images that are backlit, and colours, too, tend to be stronger and more intense. As has already been mentioned, a major advantage of shooting with the sun behind the photographer is that TTL (through-the-lens) exposure metering systems produce more consistently accurate results, since they are designed to measure the light reflecting off the subject.

What, then, are the advantages of backlighting? First, in order to appreciate the special qualities inherent in backlit scenes, you need to take particular care with getting the exposure right. If you just point the camera at the general scene, the meter will register a huge amount of light because it is facing in the direction of the sun, and it will set an aperture/shutter speed combination accordingly. Most often, an exposure taken with this type of setting will show your subject as a partial or total silhouette. If you don't want this result, simply move in close up to the subject, take an exposure reading that excludes the brightly lit general scene, lock that reading into the camera, and then move back and recompose the picture before shooting.

▲ In frontlighting, the sun is at the photographer's back and the light falls on the side of the subjects facing the camera. Any shadows cast thus fall behind the subjects, and away from the camera.

▼ In backlighting, the sun is at the subjects' back and the light falls on the side of the subjects away the camera. Any shadows cast thus fall in front of the subjects, toward the camera.

▶ In this backlit scene, the photographer has decided not to compensate fully for the extra light entering the lens, and the exposure shows the subject's faces slightly underexposed. However, the light pouring through the bride's translucent veil creates a dramatic and eye-catching contrast.

PHOTOGRAPHER:
Van de Maele

CAMERA:
6 x 6cm

LENS:
180mm

EXPOSURE:
½₅₀ second at f4

LIGHTING:
Daylight only

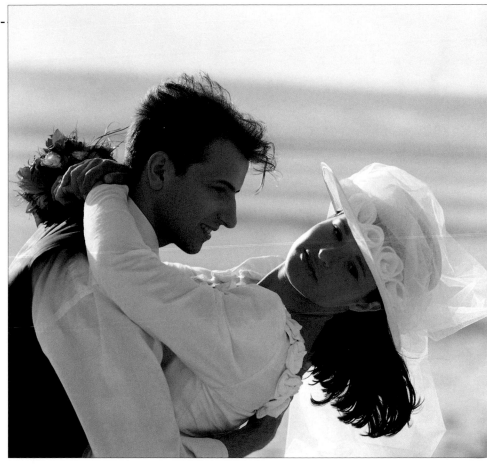

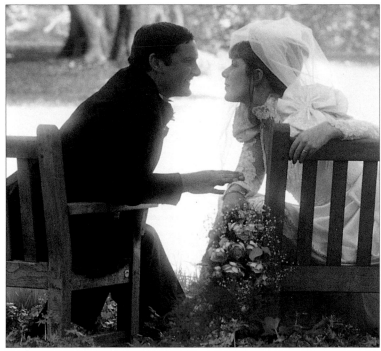

◀ Note how the shape of the figure seems to be "eaten away" as the intensely bright light of the scene beyond flares around his dark outline.

UNUSUAL SETTINGS

Before departing radically from what is normally expected from a set of wedding pictures, in terms of their style, setting, and so on, you need to discuss the matter in detail with the couple involved in order to enlist their willing support. Although the couple featuring in these photographs opted for a traditional white wedding, they were looking for a set of pictures that stood out from the crowd – a portfolio that makes you stop and take notice.

PHOTOGRAPHER:
Jonathan Brooks

CAMERA:
6 x 7cm

LENS:
80mm

EXPOSURE:
¹⁄₆₀ second at f22

LIGHTING:
Daylight only

▶ *The poses of both the bride and groom here have been carefully thought through by the photographer. The train of the bride's dress has been arranged so that it creates a repeating scalloped-edge effect as it meets each step, and her arm and hand emphasize the diagonal thrust of the railing. Again, the strong feeling of movement evident in the picture has been further reinforced by the shape of the groom's body, which echoes the diagonal lines in the frame.*

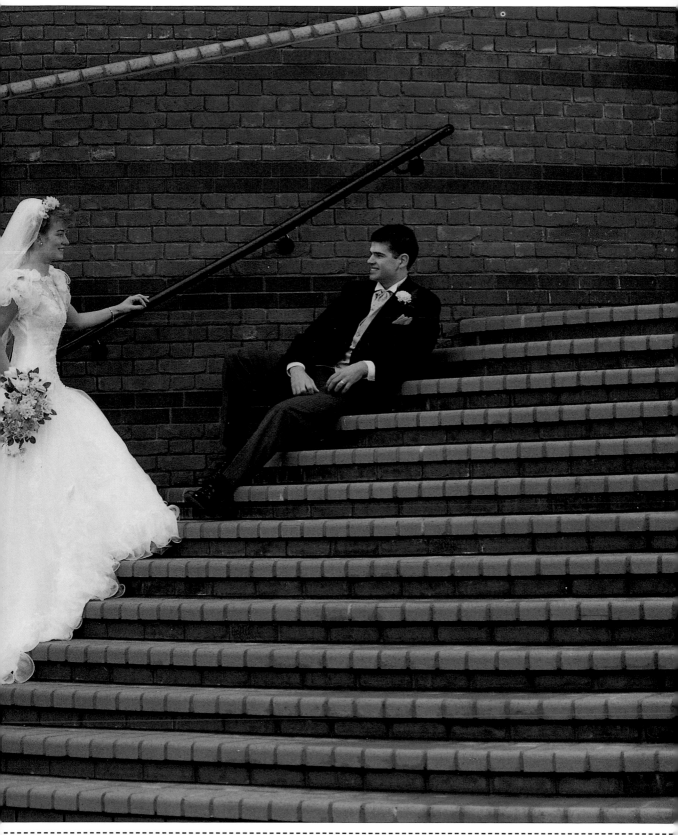

Hints and tips

● When using an outdoor public setting you may need to arrive for the photographic session early in the morning before there are too many passers-by.

● If you are using a public place to shoot in, take a broom with you. Even a small piece of paper or a discarded cigarette visible on the ground could be very distracting and spoil the picture's impact. Look carefully through the camera's viewfinder before shooting and make doubly certain that no litter can be seen anywhere in the frame.

● When framing your subjects toward one side of the frame, make sure that they are looking back into the middle of the picture. If the couple on the right of the canal-side picture had been looking toward the right of the frame, your eyes would immediately follow their gaze out of the picture area.

PHOTOGRAPHER:
Jonathan Brooks

CAMERA:
6 x 7cm

LENS:
120mm

EXPOSURE:
⅟₃₀ second at f11

LIGHTING:
Daylight only

▶ *The industrial canal-side setting for this picture has been used to excellent advantage by the photographer, creating a most unusual image – one that is full of interesting shapes and textures. His use of reflections helps to tonally lift the foreground as well, which helps prevent the reddish-brown colour of the brickwork dominating the scene.*

▲ *It is possible to introduce a strong sense of movement into a picture, even though the subjects are completely still. In the canal-side photograph, note how the photographer has framed the couple toward* one edge of the frame. This makes it a very active composition and introduces a degree of tension. If they had been centre frame, the whole feel of the picture would be very different. In both pictures you *can also see the use that the photographer has made of diagonal lines. Including these immediately add vitality to the imagery, implying strong movement, and drawing the eye through the scene.*

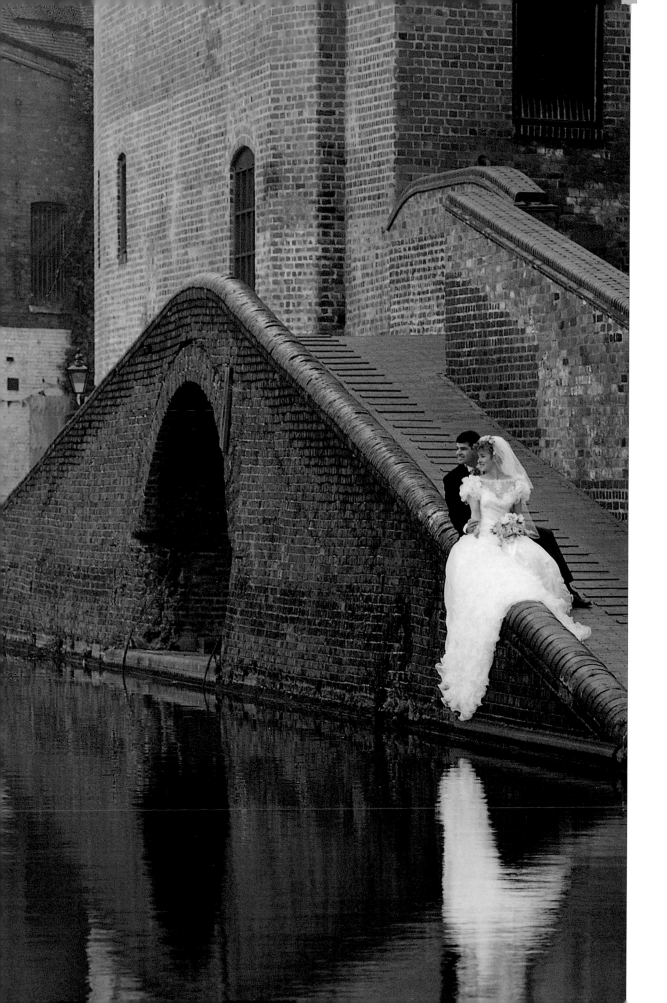

SELECTING IMAGES

There aren't many rules in photography that can't be broken, but one of the golden rules of wedding photography is that you should always shoot more film than you think you could possibly need. It is true that buying film stock and then developing and printing can work out to be expensive, but you need to bear in mind that to the participants, and their immediate families, a wedding is one of the most important occasions of their lives. It is a one-off event, and you get only one chance at taking the pictures.

If you are a friend of the family and have been asked formally to take the pictures at the wedding, or if you are a professional photographer working on a commission basis, explain that it is better to have more pictures than you will eventually want enlarged so that the completed wedding portfolio contains only the very best work. In the context of the entire wedding expense, most people will not want to skimp on this aspect.

▶ *Sheets of images printed the same size as medium-format negatives are large enough to see clearly and make decisions about which should be enlarged. Images from 35mm negatives may be a little too small, however, and it is best to order enlarged contact sheets. Don't worry if the colour balance of each image is not perfect – this can be corrected when the negatives are individually printed.*

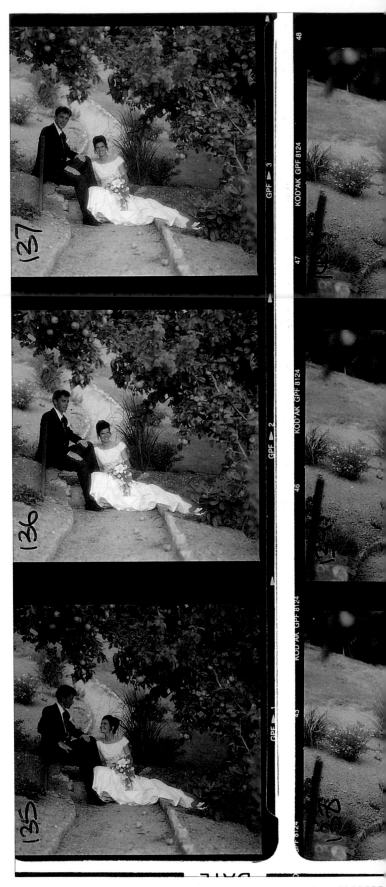

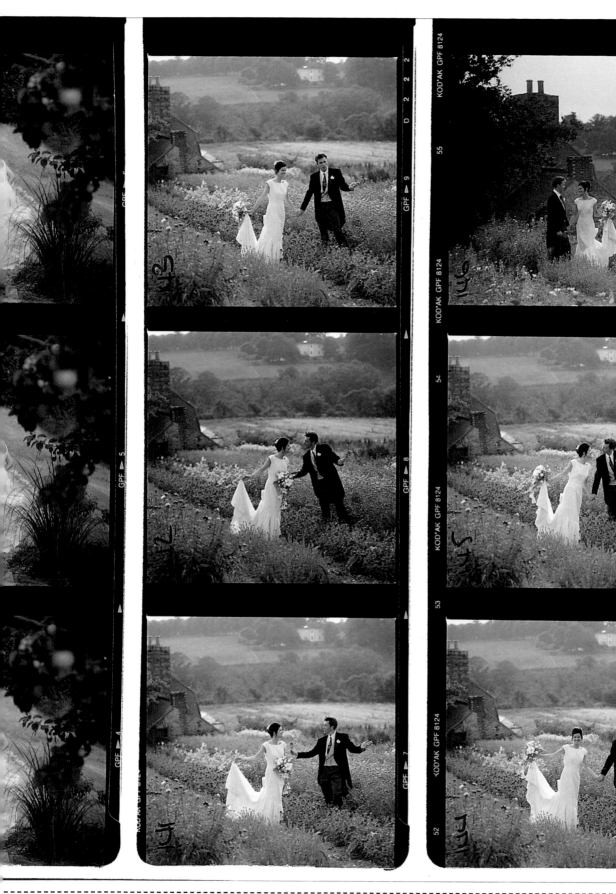

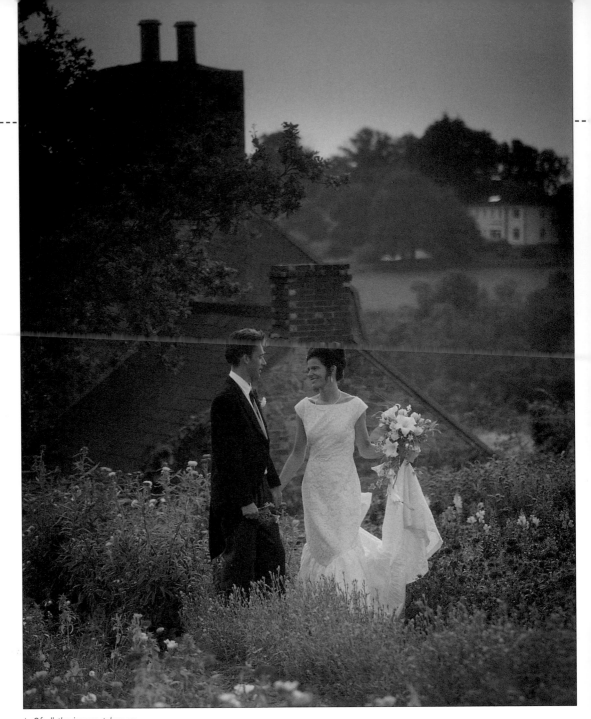

▲ Of all the images taken on this photographic session, conducted a few days before the wedding, this is the only one that managed to capture the romantic rosy quality of the afternoon sunlight. The carpet of wild flowers also makes a fitting foreground and background for the couple.

PHOTOGRAPHER:
Peter Trenchard

CAMERA:
35mm

LENS:
28-70mm zoom

EXPOSURE:
1/125 second at f11

LIGHTING:
Daylight only

EXPOSURE:
1/60 second at f11

LIGHTING:
Daylight only

▶ This image was selected because it is the one that shows the groom in the most relaxed posture. In others from that set, his back appears unnaturally stiff or his hands are held uncomfortably. Unless you take lots of nearly identical images, you may have to enlarge less-than-perfect shots.

▶ *This image is the best example of facial expressions and pose. The exposure, too, is better than in the others of this set, some of which are just a little overexposed. Slight underexposure tends to make colours look richer and can create quite dramatic lighting effects.*

EXPOSURE:
½₂₅₀ second at f11

LIGHTING:
Daylight only

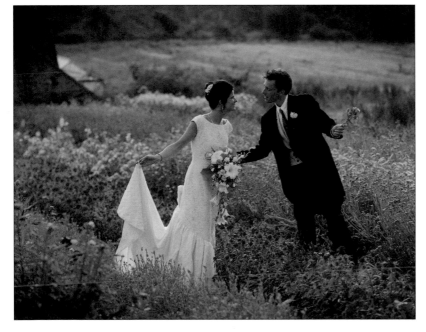

Hints and tips

● Scout out likely locations for different types of photographic sessions in your immediate area.

● Be prepared for a sudden change in weather conditions. Always have a large golfing umbrella with you that all can stand under if you are shooting far from the shelter of the car.

● Carry a ground sheet that the bride can sit on so that her wedding dress doesn't become dirty. Make sure it is arranged out of sight of the camera, however, before shooting any film.

● Vary the exposure slightly of some of your shots, especially if the poses are similar, so that you get a good range of effects from which to choose.

● Buy a good-quality magnifying glass for looking in detail at contact sheets.

FLASH AND DAYLIGHT

The extreme portability of accessory flash units (as opposed to studio flash) has made them an indispensable tool for any photographer today who is involved in location and non-studio work. The most obvious use of flash for wedding photographers is indoors – in the church, registry office, or other building where the ceremony is taking place – where light levels will probably be low unless subjects are positioned in the immediate vicinity of any windows.

When used indoors, as the sole or predominant light source, the effective range of flash, as quoted by the manufacturers, assumes that there are likely to be walls, a ceiling, and other reflective surfaces to contain the light and reflect it back onto the subjects.

Another popular use for accessory flash is outdoors where, instead of being the main light source, it is used to supplement natural daylight. Flash produces a burst of light that has, as far as the film is concerned, the same colour content as daylight, and so colour casts are not a problem. On many occasions, wedding photographers will be confronted with dull and overcast daylight, and pictures taken straight will be lacking in contrast and appear flat. Under these conditions, flash can be used to boost light levels locally, adding a bit of sparkle in order to give the impression of a sunnier day.

At the opposite lighting extreme, when daylight is very contrasty, with dense shadows and intense highlights adjacent to each other, flash can be used to lighten localized shadows to varying degrees and so preserve some subject detail there that would otherwise be completely lost.

Suppressing a background

Although flash used outdoors is very limited in range, it can have a dramatic effect on overall exposure. By positioning your subjects close to the flash source you can add enough local light to allow a shutter speed/aperture combination that underexposes the surroundings. For example, an ordinary light reading for your subjects and their surroundings may suggest an aperture of f5.6 and a shutter speed of $\frac{1}{125}$ second. By adding flash light into the calculation, the new settings for the subjects alone could be f16 or f22 at $\frac{1}{125}$ second. By using these settings to take the picture, there would be a two- to three-stop difference between the subjects and their surroundings.

PHOTOGRAPHER:
Richard Wilkinson

CAMERA:
35mm

LENS:
90mm

EXPOSURE:
$\frac{1}{125}$ **second at f8**

LIGHTING:
Daylight supplemented by flash

▶ *Flash was used here to exploit the exposure difference that already existed between the groom and the shadowy forest behind. The flash was carefully positioned so that its light reached only the subject, thus creating about a 3½-stop difference between him and the background.*

Hints and tips

● To isolate your subjects from their setting using flash, make sure that there is a sufficiently wide separation between the two to prevent light spilling over and illuminating anything other than the subjects themselves.

● If the surroundings are slightly shadowy to begin with, then using flash to illuminate the subjects alone can have an even more dramatic effect.

● Dedicated flash units – those designed to be used in conjunction only with a specific camera, or a range of cameras from the same manufacturer – measure the total amount of light reaching the film, and so ensure a high rate of successful exposures when mixing daylight and flash in the same shot.

PHOTOGRAPHER:
Nigel Harper

CAMERA:
6 x 7cm

LENS:
120mm

EXPOSURE:
⅟₆₀ second at f4

LIGHTING:
Daylight supplemented by flash

▶ *The bride and groom in this photograph were so far away from their background surroundings that the position of the flash was not that critical, although a large aperture was required to limit depth of field – the zone of sharp detail surrounding the point focused on.*

▲ *Window light, diffused by translucent curtains, is the principal light source here. The photographer took an exposure reading from the shadowy side of the subject to ensure that the image was light and bright.*

PHOTOGRAPHER:
Gary Italiaander

CAMERA:
35mm

LENS:
70mm

EXPOSURE:
¹⁄₂₅ second at f4

LIGHTING:
Daylight only

Hіgh-key portraits

One extremely effective way of creating an appropriate type of atmosphere in a bridal picture is to emphasize the lighter tones or colours of the subject, thus creating what is known as a high-key portrait. A "normal" subject is made up of a mixture of light and dark tones or colours, and an average exposure reading will endeavour to accommodate both. However, by selectively metering, or by using your camera's exposure-override facility, you can alter the picture's balance to suit your requirements.

We all associate particular colours with certain moods. Yellows and reds, for example denote heat and passion, white is for purity, and blues and greens are considered cool, reserved colours. With black and white images, predominantly dark-toned photographs are often associated with enclosed and menacing feelings, while mainly light-toned ones can seem open, airy, and full of space.

To take a high-key portrait with an averaging exposure meter, first take the reading as you would normally and then set the camera controls to give about an extra stop's exposure – either open the aperture by one f stop (from f8 to f5.6, say) or use the next slower shutter speed (⅟₁₂₅ instead of ⅟₂₅₀ second, for example). If you can take a selective exposure reading, perhaps by using a spot meter, fill the meter's sensor area with a darker-than-average colour or tone. This way, the meter will recommend or set the aperture and shutter speed you require to produce a predominantly light-toned image.

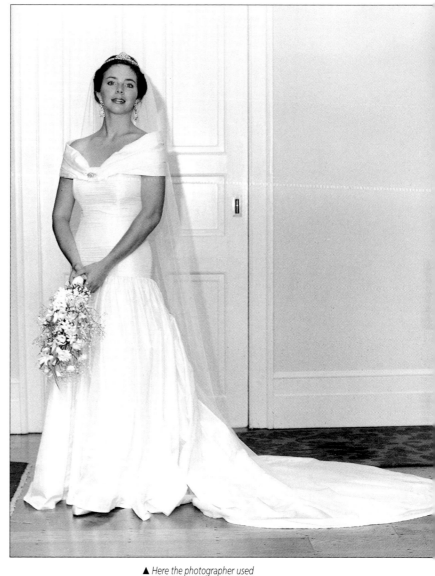

▲ Here the photographer used flash and high levels of domestic tungsten lighting to produce a high-key image. The only solidly dark tone is the bride's hair, all others being either white or light grey. Black and white film does not respond adversely to the colour components of different light sources, and so flash and tungsten can be mixed in the same photograph.

PHOTOGRAPHER:
Hugh Nicholas

CAMERA:
35mm

LENS:
55mm

EXPOSURE:
⅟₆₀ second at f8

LIGHTING:
Flash and tungsten

PERSPECTIVE

Perspective in photography is represented by the visual indicators that give the flat, two-dimensional print the appearance of having the third dimension – that of depth and distance. There are many different indicators of perspective, and the two main ones present in this photograph are linear perspective and diminishing scale. In linear perspective, lines appear to converge as they grow further from the camera, something that is very obvious when you look at the trees bordering both sides of the path. Diminishing scale is an indicator of depth and distance because we know from experience that objects appear to become smaller the further away they are – again evident in the steadily diminishing size of the tree trunks. Once you are aware of things such as perspective in photography, you can start using them to create more powerful compositions.

PHOTOGRAPHER:
Nigel Harper

CAMERA:
35mm

LENS:
70mm

EXPOSURE:
1⁄₄ second at f8

LIGHTING:
Daylight only

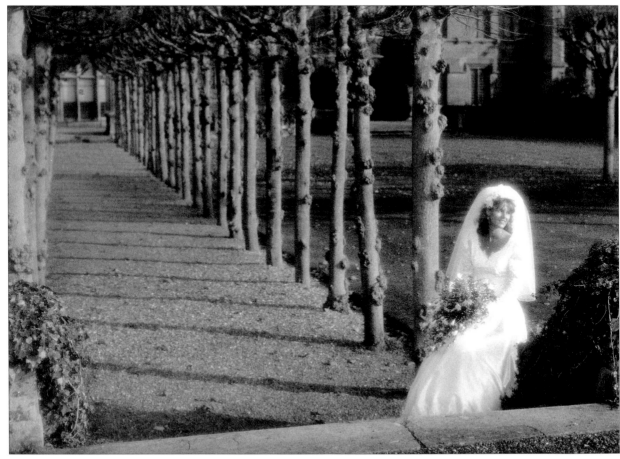

▲ In this version of the photograph, linear perspective and diminishing scale are tending to work against the composition. Your eye alights on the path and is drawn along it away from the bride, who is the main subject, even though she is tonally very different to the rest of the picture.

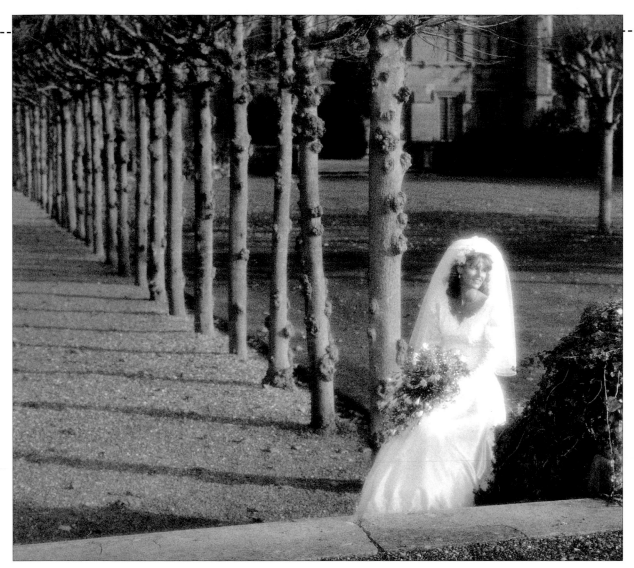

▲ In this second version, a portion of the left-hand side of the image has been cropped off during printing. At once you can see that perspective now works in favour of the composition. Instead of your eye being drawn away from the subject, as in the full-frame image, it travels from the background of the picture to the front, and comes to rest on the bride.

Linear perspective Diminishing scale

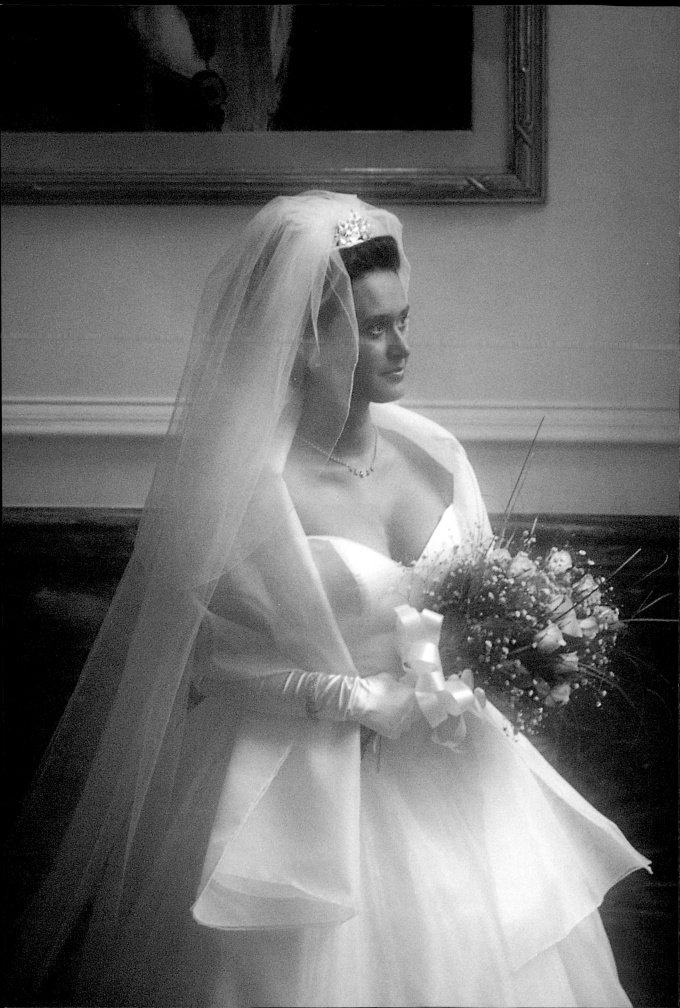

SOFT-FOCUS EFFECTS

Of the huge range of special-effects lens filters available, most intrude on the image so heavily that their use is strictly limited. One of the few generally usable special-effects filters is a diffusion filter, which is designed to soften the photographic image a little to give a slightly dream-like quality to the picture.

Diffusion, or soft-focus, filters work in one of two ways. One type has a series of concentric circles engraved on the glass of the filter. Light passing through the glass is slightly scattered, which causes details to be recorded as less sharp and for highlights to smear. The second type of diffusion filter has a slightly obscure, milky appearance, and is often referred to as a fog filter. When light passes through this type of filter, it is again scattered and the darker tones tend to become grey in colour rather than black.

◄ *A fog filter was used when taking this bride's portrait in the lobby of the reception venue. The effect of the filter is to spread the highlights, such as the light reflecting from her gown, and to mute the impact of the shadows.*

PHOTOGRAPHER:
Gary Italiaander

CAMERA:
6 x 7cm

LENS:
80mm

EXPOSURE:
⅟₆₀ second at f5.6

LIGHTING:
Flash only

Fog filter

Soft-focus filter

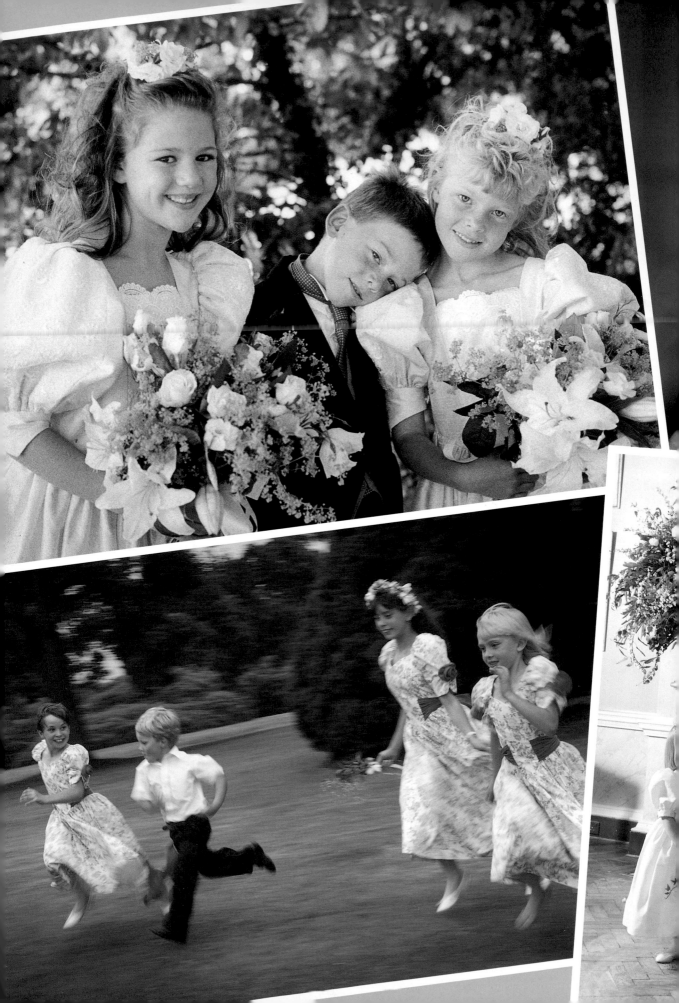

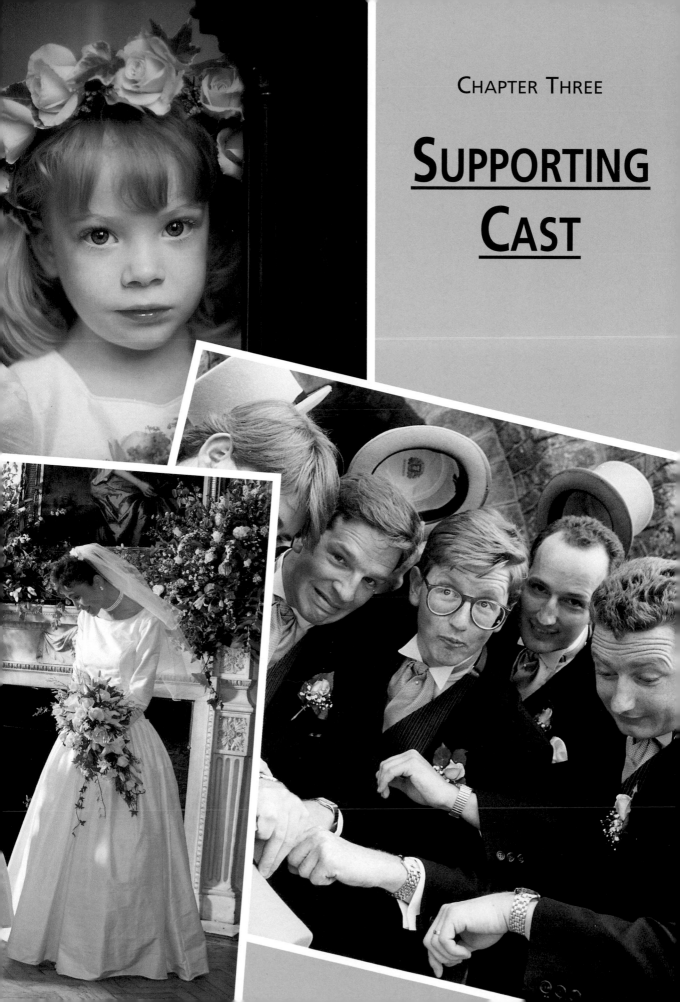

SUPPORTING CAST

RELAXED AND INFORMAL

Don't fall into the way of thinking that a group portrait needs to be somehow rigid and unrelaxed, with the subjects posed in a very formal type of way. Better informal pictures often result when you leave it to the subjects to organize themselves in a way that feels most comfortable for them. Obviously, this approach is not practical when you are dealing with a large group shot of wedding guests, since chaos may ensue. But for the three young stars of this portrait, all that was needed was the usual photographer's instruction to smile and look at the camera just before releasing the shutter.

Children tend to be a little unpredictable in front of the camera; you are never sure whether they are going to stand there wooden-like and unmoving or play up to the lens in some outrageous manner. These three were old enough, however, to realize the importance of the occasion and were mindful of the job they, and the photographer, had to do.

PHOTOGRAPHER:
Nigel Harper
CAMERA:
35mm
LENS:
135mm
EXPOSURE:
1/500 second at f4
LIGHTING:
Daylight only

◀ The original of this photograph was taken on black and white film stock. After the print was processed, it was bleached to remove some of the black silver image, and the print was then treated with special toning chemicals to produce an old-fashioned sepia colour. This gives the image a "period" feel, which is in keeping with the style of the bridesmaids' dresses and the pageboy's wing collar, tie, and tails.

Hints and tips

● If you are worried that the background to a picture may be too intrusive and compete for attention, try selecting a large lens aperture. The larger the lens aperture, the more likely it is that the background will appear soft and out of focus in the resulting print.

● If you choose a large lens aperture to show the background out of focus, make sure that you pose your subjects a long way in front of it. If they are too close to the background, both may appear sharp.

● When you use a large lens aperture, you often need a fast shutter speed to compensate for the extra light entering the camera and reaching the film. Most camera's today have exposure systems that can automatically cope with this type of situation, but you may have to select "aperture-priority" mode first.

PRETTY IN PINK

When there is a great discrepancy in height between the subjects of your photograph, you need to devise some way of getting everybody comfortably in the frame without moving back so far that you miss out on all the rich detail the scene may have to offer. One way to achieve this is to elevate the smallest member of the group, here the young bridesmaid, so that her head is about on the same level as everybody else's in the group. Outdoors, you could do this by sitting her on a wall, for example, or the back of a chair or sofa indoors, and then have the others arranged around her. Or, alternatively, you can bring everybody else down to the height of the smallest member of the group. The trick is to carry this off in such a way that the group still looks relaxed and not too obviously posed.

A bedroom was chosen for the setting of this shot because it allowed the best arrangement of the people concerned in the most appropriate setting. The bride's gown is unfussy with classically clean lines, and the brides maids' outfits, too, are uncluttered in simple pink and white stripes. The floral-printed fabrics and furnishings in the room, therefore, represent no clash, especially since a widish lens aperture was selected to ensure that not all the pattern in the room was too sharply focused.

▲ A flash unit pointing at a neutral-coloured wall or ceiling (to avoid a colour cast) returns a soft light, which often is a more flattering illumination than using direct flash.

PHOTOGRAPHER:
Desi Fontaine

CAMERA:
6 x 6cm

LENS:
80mm

EXPOSURE:
⅟₆₀ second at f4

LIGHTING:
Daylight supplemented by bounced flash

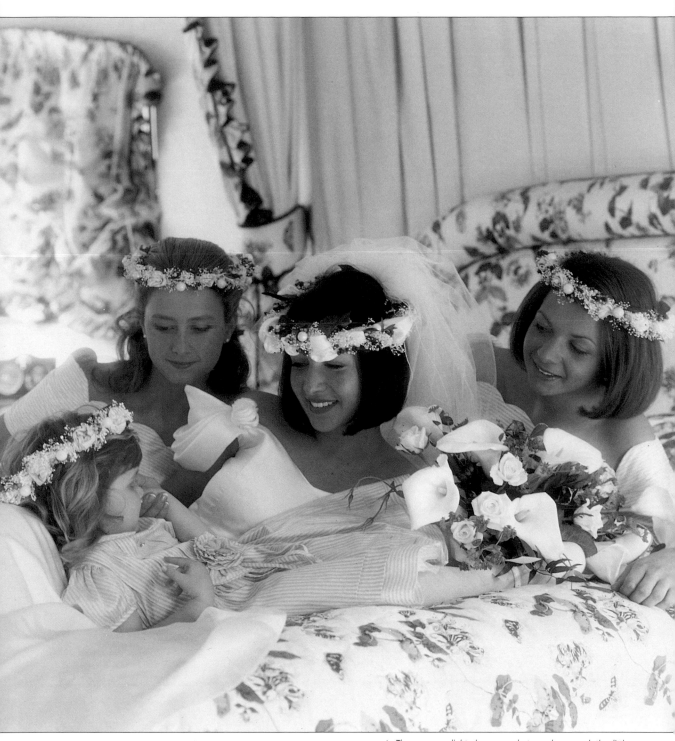

▲ There was a slight danger here that because the young bridesmaid was so small, the floral print of the bedcovers may have been a little overpowering. To prevent this, the photographer posed the little girl against the white material of the bride's dress and carried a fold of the same material under the girl's upper body to give a plain background.

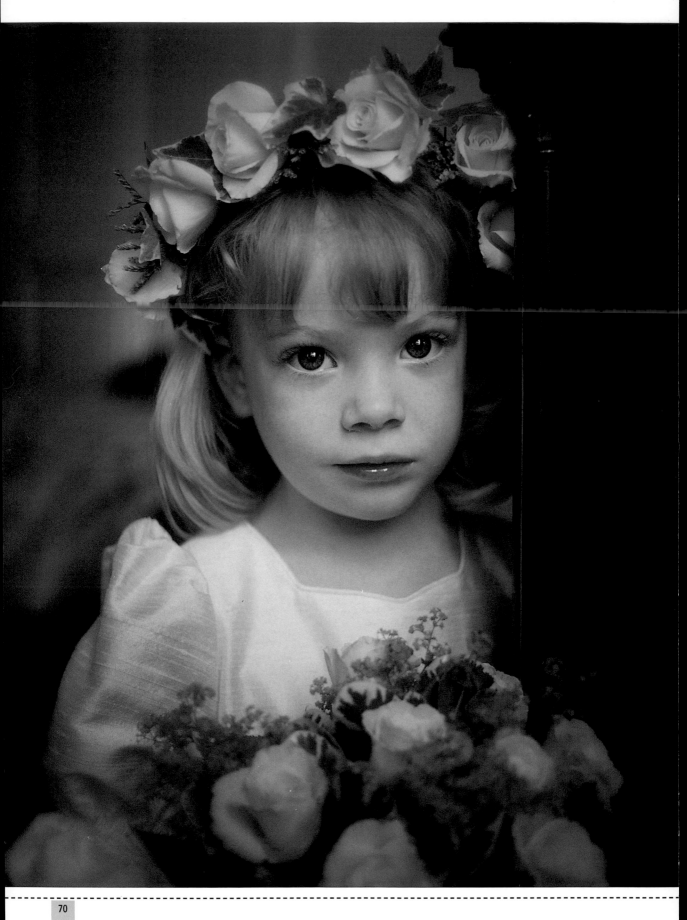

MANIPULATING DEPTH OF FIELD

Y ou can draw added attention to the subject of your photograph by ensuring that he or she is the only element in the frame that is in sharp focus. It is not always desirable to be able to see clearly every detail from the immediate foreground to the far distance, unless these details are making a worthwhile and positive contribution to the photograph as a whole. Indeed, backgrounds and foregrounds are sometimes distracting, and so it is useful to have some way of minimizing their impact as far as possible.

In the example here, the young bridesmaid's face is pin sharp, whereas the foreground flowers are slightly out of focus, and the background to the room has merged into a single, generalized tone. Every time you focus a lens there is a zone extending both in front of and behind that point of focus that is also acceptably sharp. This zone is known as the "depth of field". It is not a static zone, however, and varies in extent depending on the focal length of the lens and the lens aperture used. Wide-angle lenses have a greater depth of field at any given aperture than do standard or telephoto lenses, and small lens apertures produce a greater depth of field than large ones.

◄ *When depth of field is shallow, as here, it is vital that the subject's face is critically sharp. If you are in any doubt about where to focus, it is best to choose the eyes – if these are only slightly out of focus, the picture will be unacceptable.*

PHOTOGRAPHER:
Nigel Harper

CAMERA:
35mm

LENS:
135mm

EXPOSURE:
¹⁄₆₀ second at f2.8

LIGHTING:
Daylight supplemented by flash

| f2.8 | f8 | f22 |

▲ *You need to bear in mind that small f numbers, such as f2.8, equal large lens apertures, while large ones, such as f22, equal small lens apertures. Moving the lens aperture one full f number either halves or doubles the amount of light reaching the film. You can compensate for this by selecting the next shutter speed, which either doubles or halves the length of time the light acts on the film.*

IS THAT THE TIME?

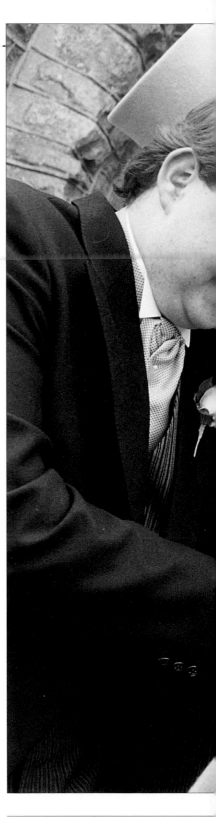

The time spent outside the wedding venue awaiting the bride's arrival can become tense. The usual doubts flash through your mind: Why is she so late? Do you think she's coming? Is that the time? Try to capitalize on this by enlisting the help of the groom and his friends to produce a light-hearted portrait. Obviously, you can't rely on this approach for the bulk of the wedding portfolio, but a shot like the one shown here may make a welcome change of mood when seen in the context of all the more orthodox pictures taken on the day.

▶ The success of a humorous picture such as this depends on the facial expressions of everybody in the shot and the clarity with which they can be seen. Therefore, either move in close with the camera if you are using a standard lens, or shoot from further back using a telephoto, to bring the faces up as large as possible in the frame. Take two or three versions of the group in quick succession and choose the one with the best expressions afterwards.

▲ The danger when taking the type of shot illustrated here is that the faces of the people in group will appear in shadow and their expressions will not be clear, which would make a nonsense of the picture. To prevent this, you can use flash to supplement the existing daylight, or position reflectors low down on either side of the group to reflect some light upward into their faces.

PHOTOGRAPHER:
Peter Trenchard

CAMERA:
6 x 6cm

LENS:
120mm

EXPOSURE:
½₅₀ second at f11

LIGHTING:
Daylight supplemented by reflectors

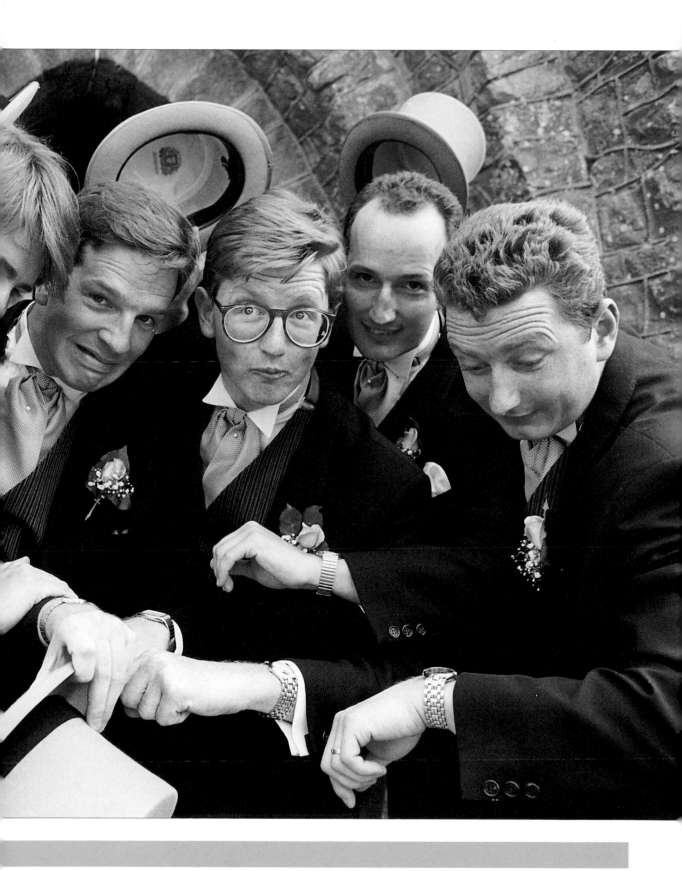

CARE WITH BACKGROUNDS

I
t is all too easy when photographing a wedding to concentrate so intently on the subjects that you fail to notice that the background to the shot is not particularly strong – or, even worse, is actually distracting. The best way to avoid this happening is to discipline yourself to look at all of the frame before pressing the shutter release.

This charming and informal portrait of the bride and her very young bridesmaid benefits from a well-conceived setting. The light for the shot is coming from one side only, through large windows out of shot on the left of the frame. The subjects are far enough into the room, however, for contrast not to be a problem. If they had been standing any closer to the window, the sides of the subjects closer to the light would have been too bright in comparison with their shadowy sides, making a single overall exposure for the picture less satisfactory.

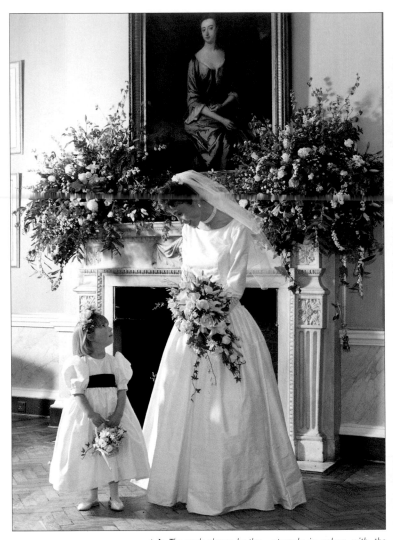

▲ ▶ The angle chosen by the photographer was determined by the need to show the bride's head in the relatively clear area between the two floral displays above the fireplace. In the full-frame image (see above), the flowers act as a type of frame, contrasting strongly in colour with the bride's headdress and visually distancing her from the background. In the cropped version (see right), the composition has been further strengthened by omitting the picture above the fireplace and some of the room details at the sides.

PHOTOGRAPHER:
Philip Durell

CAMERA:
35mm

LENS:
80mm

EXPOSURE:
¹⁄₆₀ second at f8

LIGHTING:
Daylight only

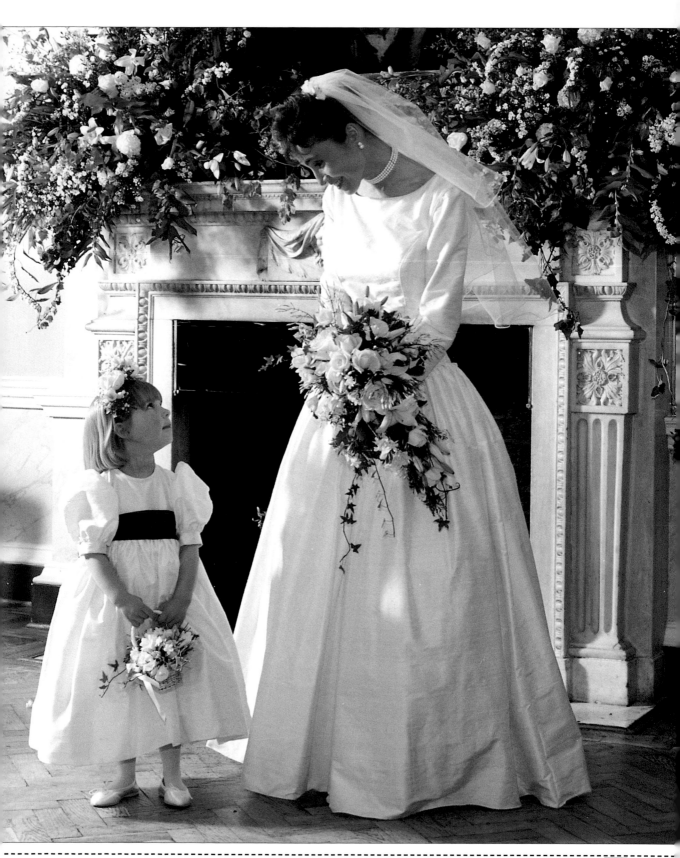

THINKING ABOUT EXPOSURE

The most frequently occurring colour at Western-style weddings is white: the most favoured time of year for weddings ceremonies is when the sun is most likely to be shining. Put these two factors together and you have a potential exposure problem. Strong sunlight reflecting back from white clothing could be so bright that the camera's exposure system will set a shutter speed/aperture combination that underexposes skin tones. You can override the camera's automatics and manually set an exposure to favour the subjects' skin tones (which would mean setting either a wider lens aperture or a slower shutter speed), but then the bride's and bridesmaids' white gowns, or anybody else's light-coloured clothing, may appear overexposed and glaringly bright – a totally unsatisfactory result. The solution to this problem is to pose your subjects where the exposure difference between different parts of the scene is only one or two lens f numbers (also known as f stops).

◄ *Where the light falls directly on the young bridesmaid's dress, all surface information has been bleached out. In the darker part of the frame, however, the folds of the dress are shown as a mixture of light and shade, and you can almost feel the satiny quality of the material.*

◄ *The white clothing of these young supporting players at the wedding ceremony would have caused impossible exposure problems if they had been posed in the bright sunlight you can just see outside the colonnade. Here, in the shadows, the photographer has found the perfect balance of exposure to give good, clean whites and well-rendered skin tones.*

PHOTOGRAPHER:
Philip Durell

CAMERA:
35mm

LENS:
135mm

EXPOSURE:
⅟₆₀ second at f8

LIGHTING:
Daylight only

What are exposure f numbers?

The figures engraved on the lens aperture ring are known as f numbers, or f stops. Every Time you select an f number one stop higher (f8 to f11, for example) you decrease the size of the lens aperture and halve the amount of light entering the camera. Selecting an f number one stop lower (say, f5.6 to f4) increases the size of the lens aperture and doubles the amount of light entering the camera.

Lens aperture ring and typical range of f numbers

Youthful high spirits

The younger members of the supporting cast of players are going to want to let of steam at some point during the wedding day. The weather at the point of the celebrations when the picture here was taken was a little dull and overcast, and so a static group portrait might have been less than sparkling. In any event, the kids were obviously bursting with energy and so the photographer encouraged them to participate in a high-spirited sprint across the lawn.

PHOTOGRAPHER:
Nigel Harper

CAMERA:
35mm

LENS:
105mm

EXPOSURE:
⅟₆₀ second at f8

LIGHTING:
Daylight only

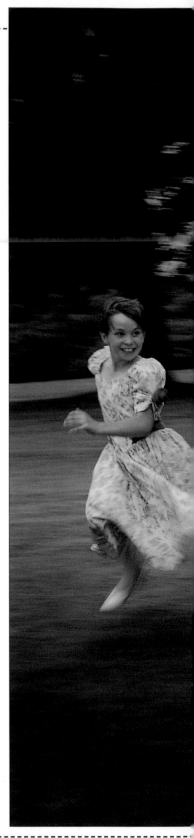

▶ The panning technique used for this photograph of the bridesmaids and page boy letting off steam away from the adults at the reception has produced a picture full of energy, action, and fun.

PANNING

To produce a panned picture, you have to move the camera to keep the subject in the frame while the camera's shutter is open and the film is being exposed. The slower the shutter speed and the faster you move the camera to keep up with the action, the more blurred all stationary parts of the scene become.

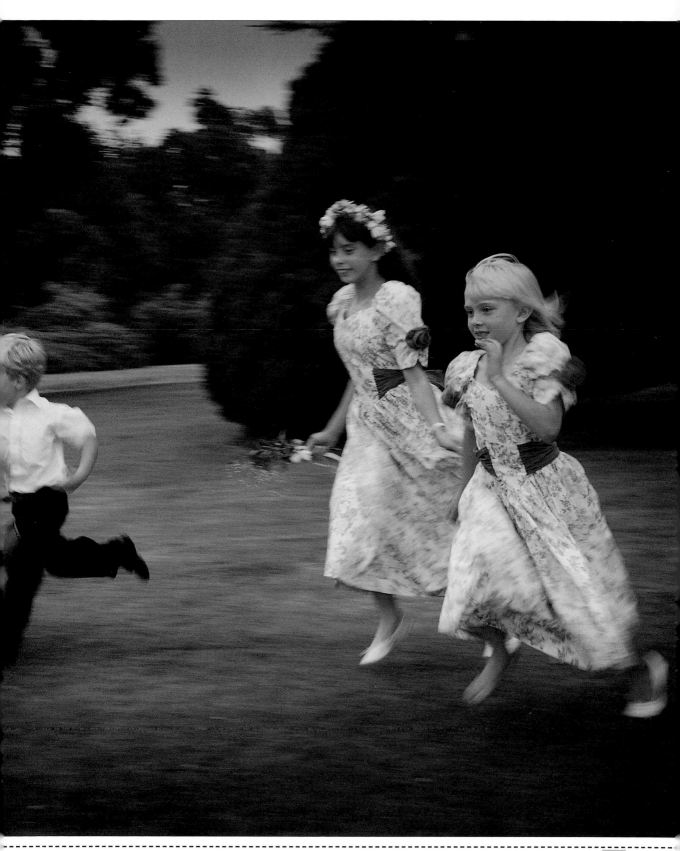

THE CEREMONY

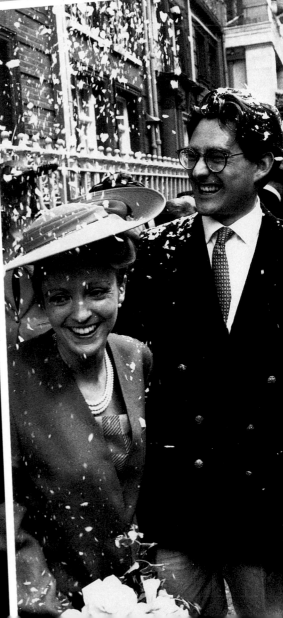

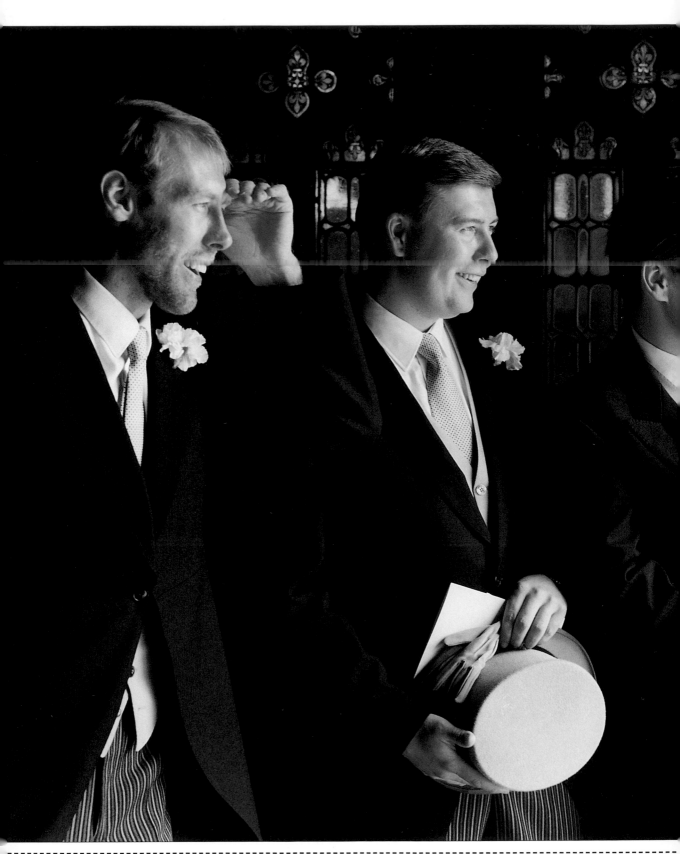

CAPTURING THE MOMENT

There is always an element of luck involved in being at the right place at the right moment with your camera loaded with film and ready to shoot. But as your experience as a wedding photographer increases, so will you be better able to anticipate where you ought to be, and when.

As the expected time of the bride's arrival draws near, it is a good idea to stay in the vicinity of the groom and his best man or the ushers. It is human nature for them to want to stay outside for as long as possible, timing their entry into the church, registry office, or wherever the ceremony is being held just before the bride's car comes into view. As the tension mounts you should be able to record a few good frames of those anxious last few minutes.

At this time of the proceedings, everybody's attention will be firmly fixed on the bride's arrival, and so you should be able to move about quite freely without drawing attention to yourself, picking off some unposed, candid shots.

PHOTOGRAPHER:
Nigel Harper

CAMERA:
6 x 7cm

LENS:
120mm

EXPOSURE:
½₂₅₀ second at f8

LIGHTING:
Daylight only

◄ *When this photograph was taken, the bride was already running a little late in arriving at the church. The photographer could sense the tension beginning to build in the ushers, who were still standing outside. Waiting for just the right moment to shoot, he released the shutter as soon as he saw one of the ushers lift his hand to shade his eyes as he strained to catch the first sight of the bride's car. Although this is only a small gesture, it makes a world of difference to the impact of the final photograph.*

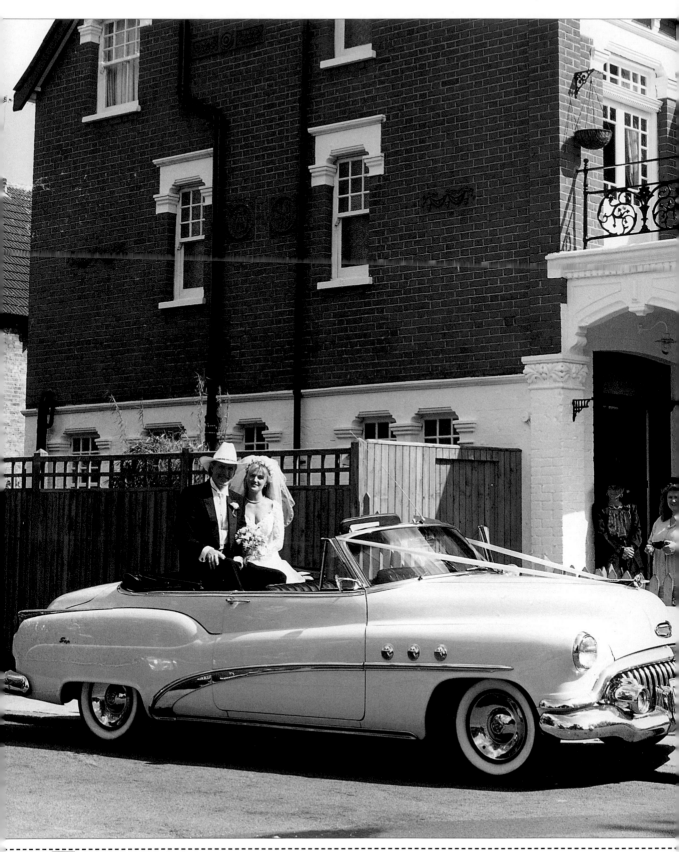

ARRIVING AND DEPARTING

Many couples put a lot of thought, and often a considerable amount of money, into how they get to, or depart from, the wedding ceremony. It may help if you think of the whole wedding day, and the activity leading up to it, as a piece of theatre: the participants attend rehearsals, dress up in extravagant costumes, and make their entrances and exits all according to prearranged cues and signals. Everything is designed to leave a happy and memorable impression on the audience.

As part of this theatrical performance, many couples opt for an unusual mode of transport, such as a vintage car or horse-drawn carriage. As part of the shot-list agreed on before the wedding day, the photographer should be briefed to expect something like this so that he or she can be prepared – additional time may be required, for example, or the photographer might want to use a lens not normally required for wedding coverage, or may want to use a special lighting set-up or some non-standard effects filters. The more the photographer knows in advance, the better the resulting photographs are likely to be.

Some photographic studios, ones that specialize in weddings, are able to provide clients with a package that includes the transport to and from the ceremony. If you are interested in this type of deal, you may be able to choose from a range of unusual or vintage cars, motor bikes, horse- or pony-drawn carriages, and so on. If you decide on, say, a vintage car or old-fashioned horse and carriage, you may decide to carry this theme through with a period-style bridal gown and bridesmaids' outfits. The groom and best man could also join in the performance by buying or hiring suits of the appropriate period.

◀ *This couple's choice of transport from the church to the reception was a collector's car dating from the 1950s – huge, with white-wall tyres and masses of chromework. In keeping with the American theme established by the car, the groom is sporting a 10-gallon western-style hat.*

PHOTOGRAPHER:
Desi Fontaine

CAMERA:
6 x 6cm

LENS:
80mm

EXPOSURE:
$\frac{1}{250}$ second at f11

LIGHTING.
Daylight only

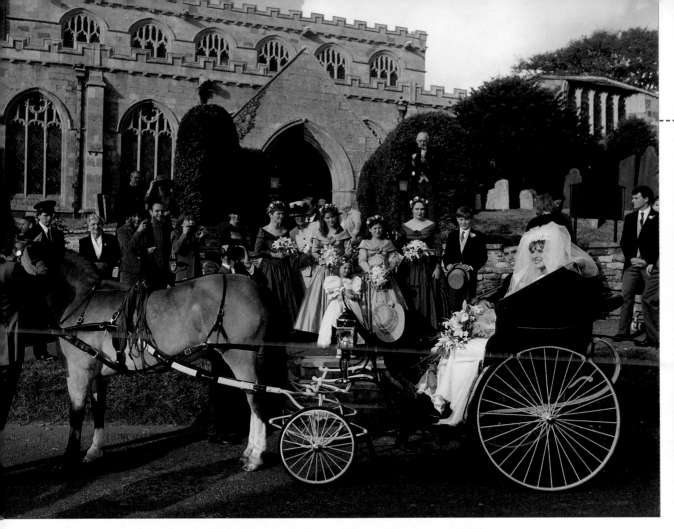

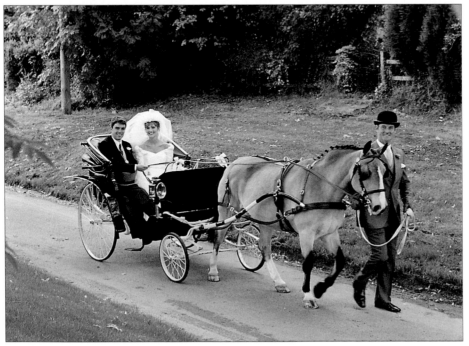

▲ ◄ *Because a horse and car-riage is such a romantic mode of transport, try to organize as many photo opportunities as possible. In the first image here (see above) this camera angle was chosen because it was the best way to use the church building as a backdrop. In the other (see left) we have a less-cluttered view of the couple on their way to the reception. The use of the out-of-focus branch and foliage in front of the camera lens helps to establish the immediate foreground, and so enhances the picture's sense of depth and distance.*

PHOTOGRAPHER:
Nigel Harper

CAMERA:
35mm

LENS:
80mm

EXPOSURE:
⅟₁₂₅ second at f16 and ⅟₁₂₅ second at f5.6

LIGHTING:
Daylight only

▼ The transport provided for this wedding was a pair of Harley Davidson motorbikes. However, the best man could not resist getting in on the shot, which also features the groom. Before taking this picture, the photographer's foresight was rewarded when she was able to conjure up a chamois cloth to wipe the worst of the rain off the gleaming machines.

PHOTOGRAPHER:
Desi Fontaine

CAMERA:
6 x 6cm

LENS:
120mm

EXPOSURE:
⅟₆₀ second at f4

LIGHTING:
Daylight supplemented by diffused flash

▼ *A vintage Rolls Royce is regarded by many as being the most appropriate of wedding-day transport. By arrangement, this Rolls was hired for a few extra hours the day before the wedding for a photographic session in the woods.*

PHOTOGRAPHER:
Richard Wilkinson

CAMERA:
6 x 7cm

LENS:
80mm

EXPOSURE:
¹⁄₆₀ second at f16

LIGHTING:
Daylight supplemented by bounced flash

▲ *A flash-synchronization cable connects the camera's shutter to the flash, which is set up facing into a silver-coloured flash umbrella. The light reaching the subject this way is much softer and more flattering than you would get from using flash pointing directly at the subject.*

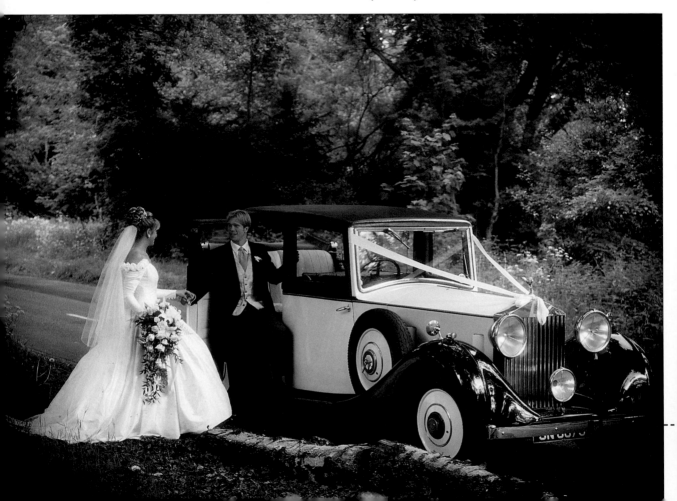

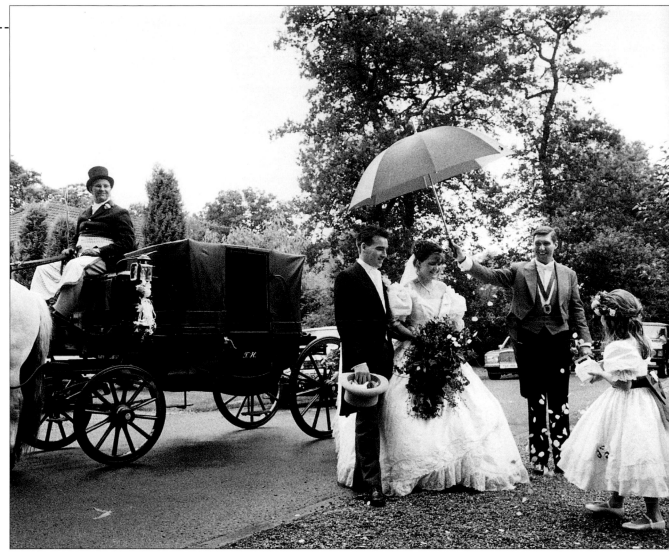

▲ *A horse-drawn carriage was the inspiration for this period treatment. As you can see, the bride and bridesmaid are both in Victorian-style gowns, while the groom's top hat and tails, although modern, are little changed since those times. Even the driver, with his protective apron, look just the part. As the perfect finishing touch, some of the images were sepia toned to give them a turn-of-the-century look.*

PHOTOGRAPHER:
Nigel Harper

CAMERA:
35mm

LENS:
35mm

EXPOSURE:
⅙₀ second at f11

LIGHTING:
Daylight only

SEPIA TONING

Sepia toning black and white prints is not difficult. Special toners can be bought at any large photographic store, or you can mix up your own chemicals consisting of a bleaching agent and toner:

Bleaching agent

Potassium ferricyanide	50g
Potassium bromide	50g

Dissolve in water to make up 500ml of solution and dilute 1:9 before using

Toner

Sodium sulphide	25g

Dissolve with water to make up 500ml of solution

Warning!
You need to take particular care when mixing and using chemicals of any description, but especially acids. Wear rubber gloves when handling all bleaching and toning chemicals and solutions, even if diluted.

READY TO GO

One of the most difficult aspects of the wedding photographer's job is being in at least two places at the same time. One of the "can't be missed" shots is illustrated here – the bride and her father have arrived for the ceremony, the bridesmaids are sorting out the train of the bridal gown before they all enter the church, and everybody is just about ready to go. At the same time, however, the photographer needs to be inside the church itself so that he can take some shots of the bride and her father walking down the aisle, while somehow being in his prearranged position to cover shots of the actual ceremony. Once the service starts, the photographer's movements are very restricted because of the potential distraction too much activity might cause.

▶ With the bride and her entourage in the street, which can be a visually complex setting, and with many of the guests milling about, you need to find a camera angle and composition that simplifies the scene and so prevents all the other pictorial elements crowding in to the detriment of the final image.

PHOTOGRAPHER:
Philip Durell

CAMERA:
6 x 7cm

LENS:
80mm

EXPOSURE:
1/125 second at f16

LIGHTING:
Daylight supplemented by flash

▲ A circular or elliptical composition, as demonstrated in this illustration, creates a self-contained unit – almost a picture within a picture. The eye of the viewer travels around from figure to figure, and attention is held firmly within this area of the frame – just where the photographer wants it.

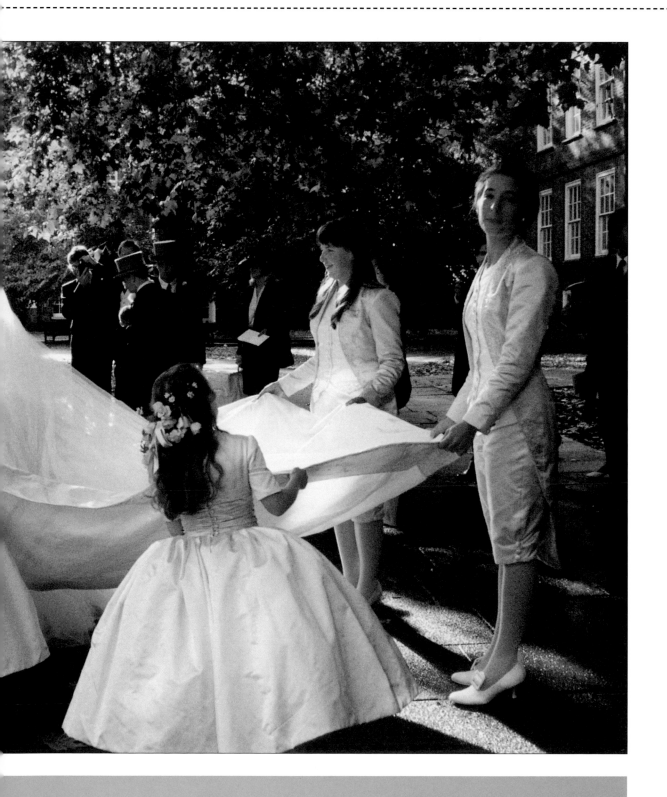

FINAL ADVICE

Photographs of the informal moments of the wedding day are sometimes more important to the couple than the traditional set-piece shots – people say that it helps them to bring back the emotions they were feeling at the time. It is impossible to know what the father opposite was really saying to his daughter as they entered the church, but it appears that he is giving her some final piece of advice – or just joking to get her to relax. What is important, however, is that every time they look at the picture, they will remember exactly how they were feeling.

PHOTOGRAPHER:
Majken Kruse

CAMERA:
35mm

LENS:
150mm

EXPOSURE:
1/30 second at f5.6

LIGHTING:
Daylight only

PHOTOGRAPHER:
Richard Dawkins

CAMERA:
35mm

LENS:
105mm

EXPOSURE:
1/60 second at f8

LIGHTING:
Daylight only

▼ In this church scene, it appears that it is the father of the bride who has been given some final advice. They have just entered the church and as all eyes turn toward them his daughter has whispered for him to button his jacket.

▶ Using a manual camera, with the focus and exposure set before the arrival of the bride and her father, the photographer was able to concentrate on the composition of the photograph – waiting for just the right moment to shoot.

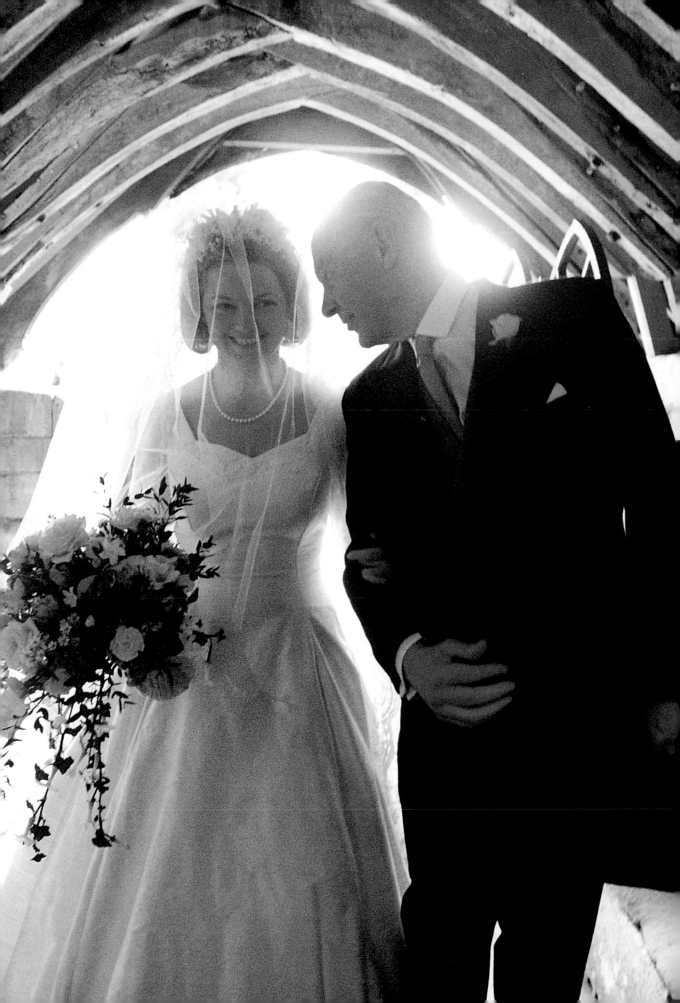

USING THE SETTING

Churches, registry offices, and other venues where wedding are celebrated are often large and sometimes austere places. Even if there is some degree of ornamentation, this can be lost in corners and niches, or high up in the roof spaces where the light does not penetrate. Where you have a church setting like the one shown here, which is not only rich in paintings, carvings, and decorative stonework but is also well lit, make the most of it.

PHOTOGRAPHER:
Philip Durell

CAMERA:
6 x 7cm

LENS:
50mm

EXPOSURE:
⅟₆₀ second at f5.6

LIGHTING:
Window light supplemented by two flash units

▶ *This glorious and highly ornate church makes the perfect setting for photographs of the couple taking their wedding vows. Natural light from windows on both sides of the church produced a good level of illumination, but this was further supplemented by light from two flashguns.*

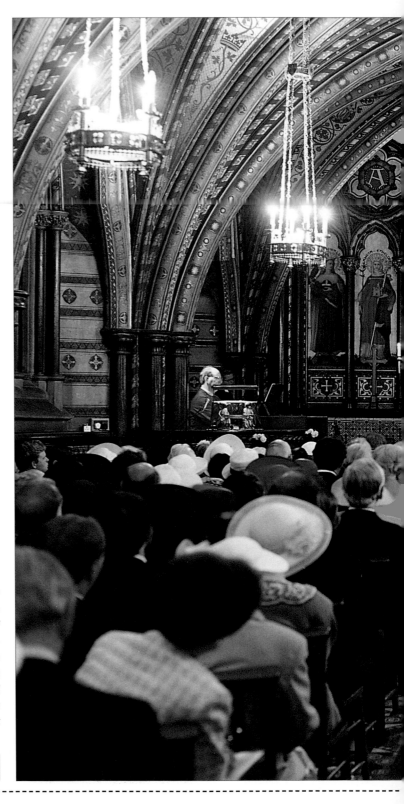

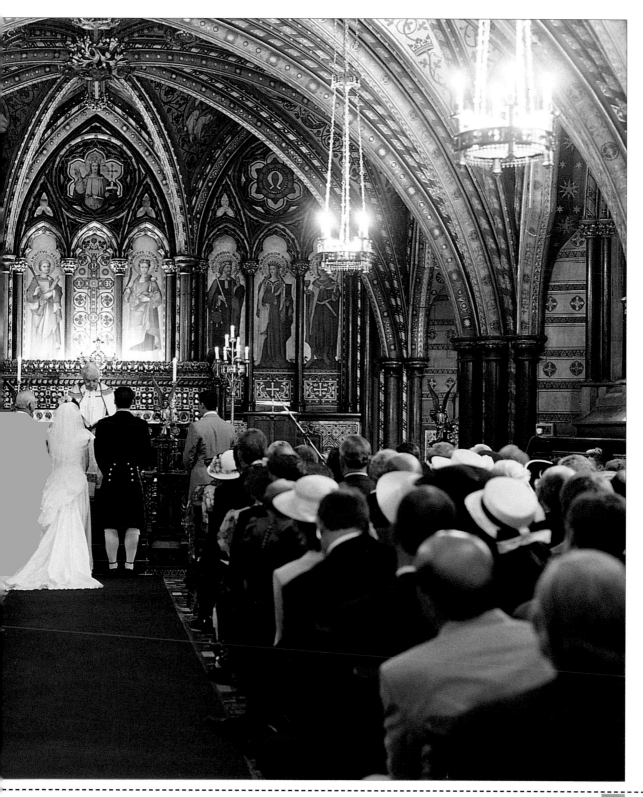

CHOICE OF FRAMING

While the wedding ceremony is being conducted, the photographer has very little opportunity to move around to find the best shooting position. Too much movement, and its associated noise, will simply be an unwanted distraction.

Before the ceremony, then, is the best time to scout out the most revealing vantage points – in terms both of what the lens actually encompasses of the scene and where the available light within the building produces the most aesthetically pleasing results. If possible, visit the church, registry office, or wherever the ceremony is to take place the day before, but at the same time of day as the wedding you will be photographing. This way, you will be able to judge exactly how the light will affect the scene on the actual day and, thus, where you should position yourself to take advantage of it. Then, once you have covered the shots outside the church and the arrival of the bride, you can go straight to your preselected camera position.

The photographic coverage of any event is usually better if there is a variety of framing, ranging from long shots through to more detailed mid-shots and close-ups. When your mobility is restricted, and you don't have the time to stop and change lenses, the best way of achieving this variety of framing is to use a zoom lens.

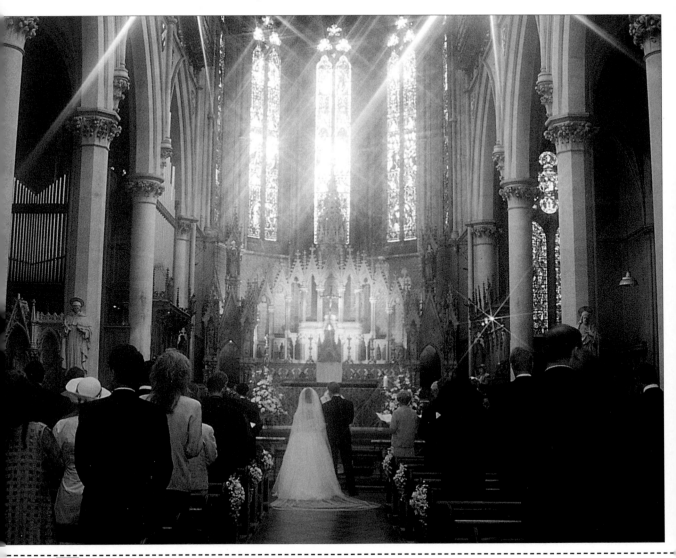

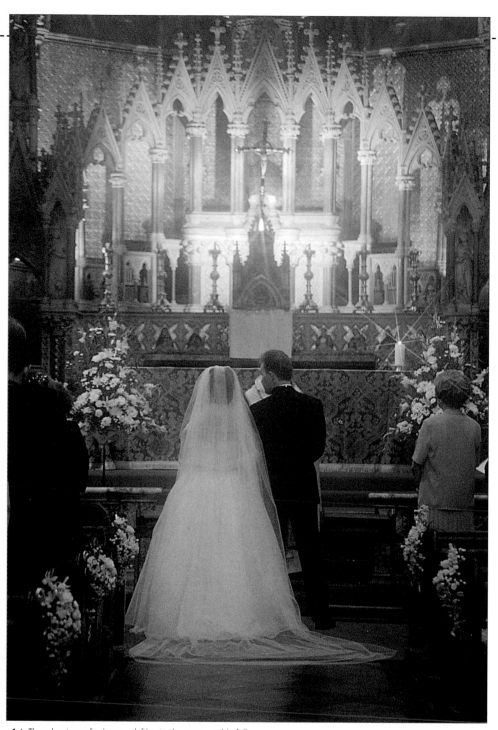

PHOTOGRAPHER:
Gary Italiaander

CAMERA:
35mm

LENS:
70-210mm zoom

EXPOSURE:
¹⁄₆₀ second at f16 and f5.6

LIGHTING:
Window light and tungsten

EFFECTS:
Starburst filter

▲ *Starburst filters have a series of fine lines engraved on their glass surfaces designed to spread point sources of light into starburst patterns. The number and pattern of engraved lines determine the number of points the starbursts will have. A side effect of using this type of filter is that images appear quite soft overall. Starbursts are more prominent at small lens apertures. You can see in the closer shot (see left), that the photographer has opened up the lens aperture to compensate for the loss of some window light as he zoomed the lens in tighter. As a result, the starburst coming from the candle to the right of the couple is not as obvious.*

◄▲ *The advantage of using a zoom lens to alter the framing of your shots can be seen in these two pictures. Both were taken from the same camera position at the back of the church. The wider view (see left) sets the scene and is full of atmosphere, while the mid-shot (see above) focuses the viewer's attention firmly on the couple taking their vows. For both shots, the lens was fitted with a starburst filter.*

GAINING HEIGHT......

I f permission to take pictures during the wedding ceremony is given, there is usually an assurance required that the photographer will not disturb the ceremony in any way or distract attention from the solemnity of the occasion. If you decide to shoot from the body of the church or registry office, there is the potential problem that part of the scene may be obscured by members of the congregation in front of you or, alternatively, you may obscure other people's view if you move in front of them too close to centre stage. Additionally, by being at approximately the same level as any ground-floor windows, there is the persistent danger that meter readings may be distorted by light hitting the lens from the windows opposite.

The solution to both these problems is to shoot from a high vantage point. Many churches have an upstairs gallery that should offer an uninterrupted view of the ceremony, since you will be shooting above people's heads (and their hats). Windows, too, are likely to cause less of a meter-reading problem because the light from them will not reach the lens directly.

PHOTOGRAPHER:
Hugh Nicholas

CAMERA:
35mm

LENS:
70mm

EXPOSURE:
⅟₆₀ second at f8

LIGHTING:
Daylight and tungsten

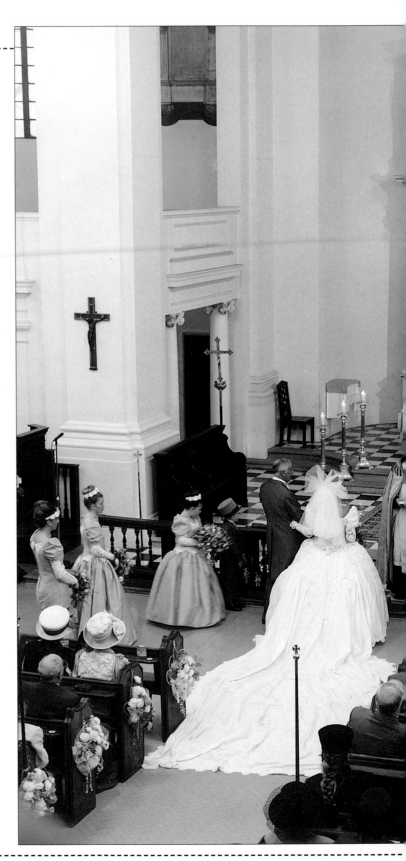

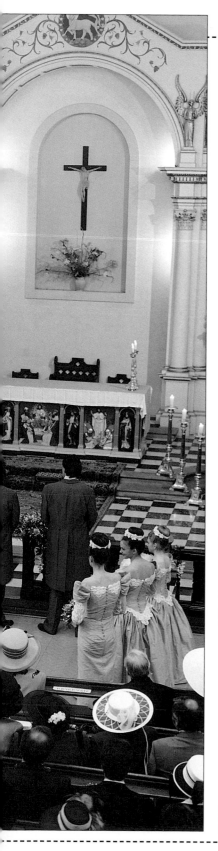

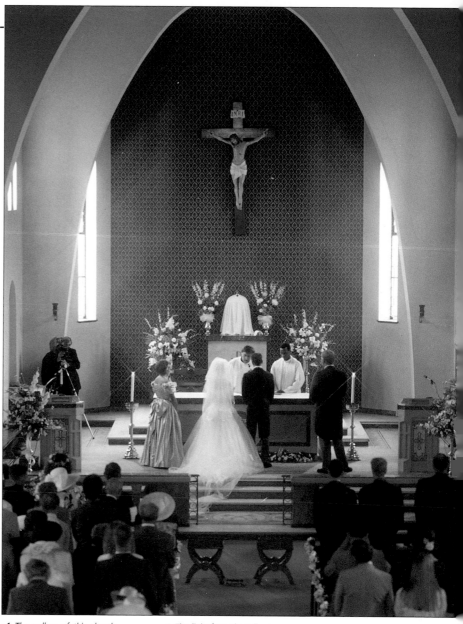

◄ The gallery of this church provided the photographer with the perfect vantage point to cover the wedding ceremony. The photographer could move quite freely along the gallery, taking full advantage of different shooting angles.

▲ The light from the tall windows to the left and right of the wedding couple was bright enough to cause some metering problems in this church. But by shooting from above there was no danger of the meter being over-influenced by direct light. The starburst from the candles either side of the couple, produced by a starburst lens filter, provide additional interest.

PHOTOGRAPHER:
Mandi Robson

CAMERA:
6 x 6cm

LENS:
80mm

EXPOSURE:
1/30 second at f5.6

LIGHTING:
Daylight only

SIGNING THE REGISTER

One of the classic wedding portfolio photographs is a shot of the couple signing the register after the ceremony is concluded.

Often, the register is placed on a table where there is plenty of free space in front to shoot a normal head-on portrait. The usual arrangement is the bride seated, pen in hand, poised over the register, with the groom standing behind. In the church illustrated in this photograph, however, this approach was clearly impossible because, as you can see, the table supporting the register abuts the church wall. Organizing the positions of the bride and groom so that both their faces were fully visible would have meant placing them in an unnatural looking pose.

PHOTOGRAPHER:
Nigel Harper

CAMERA:
6 x 6cm

LENS:
75mm

EXPOSURE:
⅛ second at f4

LIGHTING:
Bounced flash supplemented by a little daylight

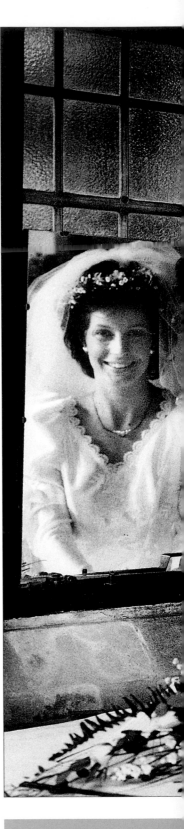

▶ Rather than having the bride turn her head to face the camera, which would have looked slightly awkward, the photographer propped a mirror up in the window recess and framed the shot so that the groom's face was visible directly and the bride's indirectly as a reflection in the glass.

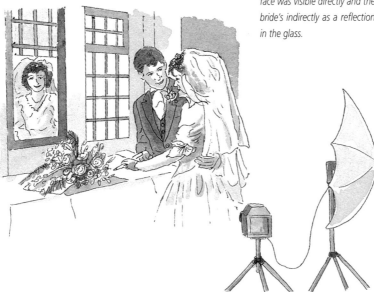

▲ The frosted glass in the window of the church recess did not allow sufficient light for the photograph. To boost light levels, flash was used. However, direct flash would have produced harsh, ugly shadows on the faces of the couple and the wall behind, as well as potential hot spots in the glass of the mirror and windows. To create the right type of natural lighting effect, the flash was directed into a flash umbrella to soften and diffuse it.

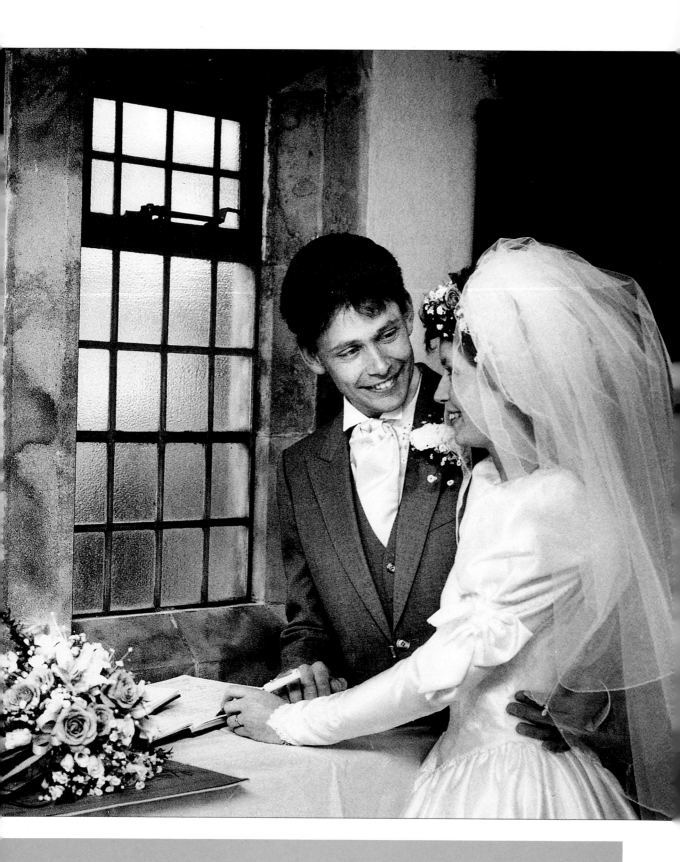

CANDLE-LIT SEND-OFF

M ost couples pray for bright sunny weather on their wedding day. Even when the sun fails to materialize, a good photographer will go to a lot of trouble to try and add a little sparkle to the photographs of the day's events, usually by using flash to simulate sunlight. For a completely different approach, at least for one or two of the set-piece shots, why not use candle light instead of daylight as your main source of illumination?

The most obvious difficulty with this experimental approach to wedding photography is that candles produce relatively little light. To overcome this, use a combination of fast film (at least ISO 400), a camera with a B (brief) or T (time) setting (or one that can be set to give an exposure of up to 4 seconds), and a lens with a wide maximum aperture. To avoid any problems to do with camera shake when using a slow exposure, the camera must either be mounted on a tripod or supported on some other firm surface.

Hints and tips

● To make sure that the couple are shown against a completely black, featureless background, you must exclude all extraneous light from the scene. Here, the newlyweds are standing in front of the heavy wooden doors that lead from the church porch to the outside, and the doors are, in turn, covered with heavy velvet drapes normally used as draft excluders when the church is in use during the winter months.

● Even with the camera mounted on a tripod, it is best to fire the shutter using a cable release. Pressing down on the release button with your finger could transmit enough vibrations to the camera to cause slight camera movement, which would be noticeable because of the very long exposure time needed.

● Because this is an experimental approach, take two or three pictures using different lens apertures or shutter speeds, and pick the best result afterwards for enlargement.

PHOTOGRAPHER:
Nigel Harper

CAMERA:
35mm

LENS:
50mm

EXPOSURE:
3 seconds at f5.6

LIGHTING:
Candle light

▶ *The only light used to expose the film for this photograph came from the candles held by the diminutive bridesmaids. The shutter was held open using a cable release for a manually timed exposure of 3 seconds, during which time all of the subjects had to stand as still as they could. As you can see, the little bridesmaid on the left and also the one closest to the camera on the right did move a little and so they appear slightly blurred.*

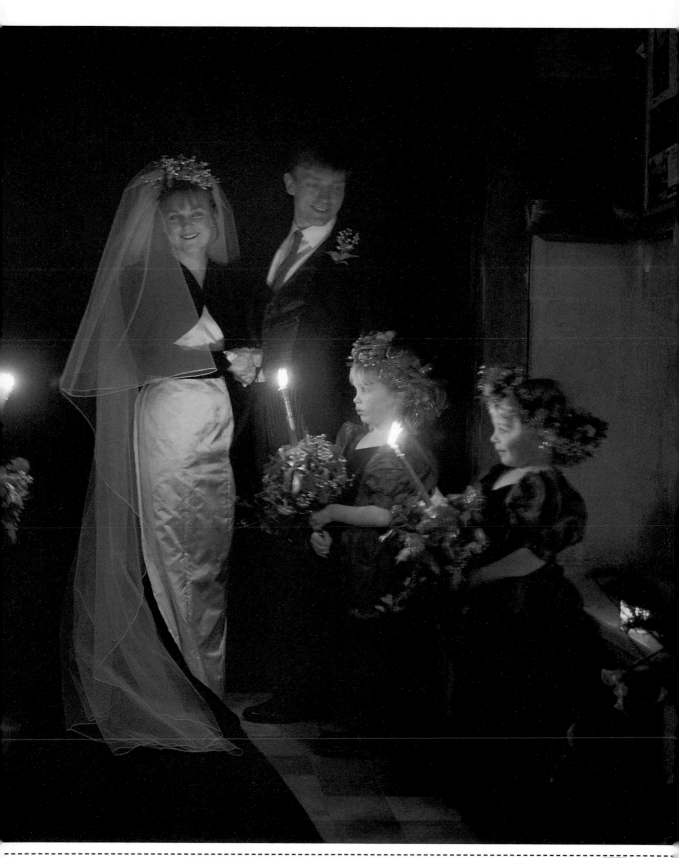

ATTENTION TO DETAIL

On the day of the wedding itself, there is usually very little time to take what could be described as thoughtful or carefully composed photographs. The time pressure on all concerned is great – perhaps the church has to be vacated at once to make way for another wedding ceremony, or everybody may have to set off almost immediately in order to get to the reception on time.

If the couple are willing, and their budget permits, it is an excellent idea to set some photographs up on a day other than the actual wedding day. In this way, you will be able to spend the time required to do justice to the importance of the occasion. Immediately after the wedding, most newlyweds go on honeymoon, and waiting for their return will delay the entire wedding portfolio. It's far better, therefore, to arrange for an additional photography session a day or two before the ceremony – assuming, of course, that they are not concerned about the superstition that the groom should not see the bride's dress before the wedding day itself.

▶ *The success of this picture relies on the care and attention that has gone into the arrangement of the bride's gown, and the precisely selected camera position. The couple's semi-silhouetted forms, and the dark, shadowy recesses of the church porch, act as a striking and dramatic contrast to the satiny whiteness of her gown.*

▲ *A slightly low camera angle (above left) accentuates the statuesque quality of the couple while showing their faces, poised for a kiss, against the uncluttered background of a tiled roof in the distance. If the same shot had been taken from a normal standing position (above right), their faces would have been lost against a confusion of background foliage.*

PHOTOGRAPHER:
Nigel Harper
CAMERA:
6 x 6cm
LENS:
120mm
EXPOSURE:
¹⁄₆₀ second at f16
LIGHTING:
Natural daylight

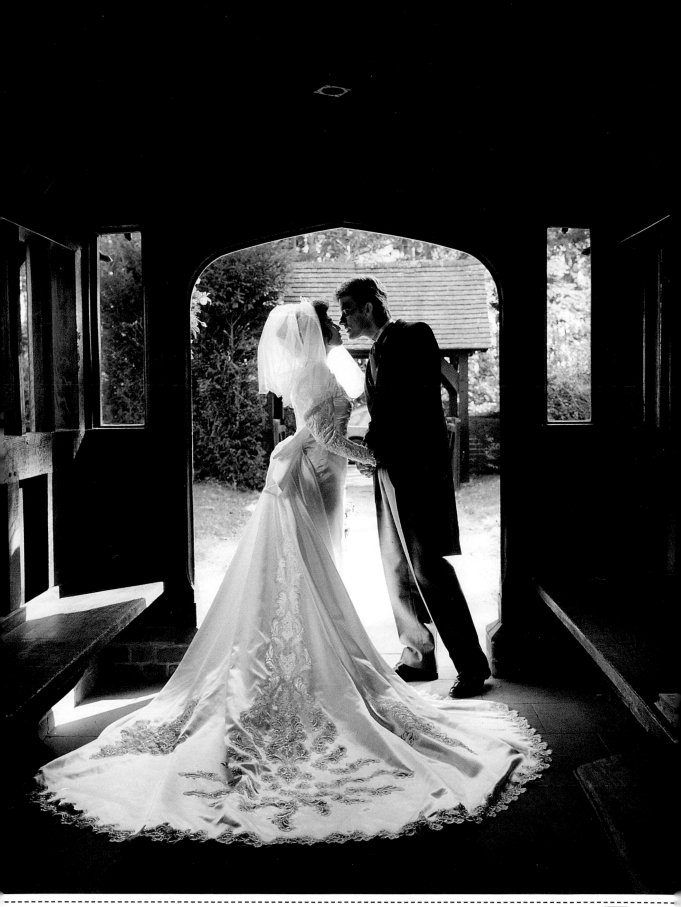

AFTERNOON SUNLIGHT

As the sun moves in an arc through the sky during the course of the day, the different qualities of its illumination can bring about dramatic changes in the appearance of your subjects.

First thing in the morning, the sun is low in the sky, shadows are long, and the colour and quality of its light can be soft and flattering. At noon, with the sun more directly overhead, shadows are short and, although images may be sharp and crisply detailed, contrast can also be harsh and unkind to facial features. As the afternoon progresses, the sun begins to move lower in the sky once more, shadows lengthen again,

and the quality of light takes on more the appearance of morning illumination.

The principal disadvantage when working with a low afternoon sun is the possibility that the sun itself will appear within the frame, flooding the scene with excess light and making the meter reading unreliable for the main subject. To overcome this, choose a camera position that shows your subject away from the sun or, if this is not possible, use some natural cover within the scene to shield the lens from its direct rays. In this example, the photographer has positioned himself so that the top right-hand segment of the arch fulfils this function.

PHOTOGRAPHER:
Nigel Harper

CAMERA:
6 x 7cm

LENS:
80mm

EXPOSURE:
½₅₀ second at f16

LIGHTING:
Daylight only

▲ The low position of the sun in the sky sends a spotlight of illumination through the archway of the church and onto the bridesmaids (above left). If, however, the sun had been slightly higher in the sky (above right), the young girls would have been lost in the shadows and much of the impact of the resulting photograph would have been lost.

▶ The importance of eyeline – where the subjects are looking – cannot be overemphasized in photography. Here, the bride is looking back over her shoulder directly at the camera. This immediately engages you as the viewer and holds your attention. The groom, however, is looking back, directly at the seated bridesmaids, thus drawing them into the image. Their gazes in turn take you back once more to the wedding couple, making this an extremely neat composition.

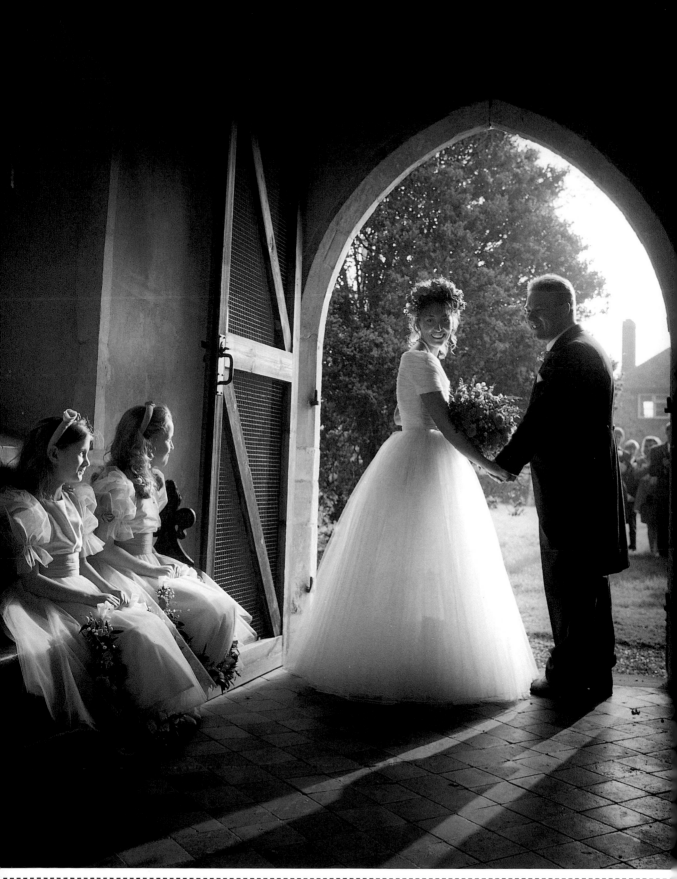

TAKE TWO

I f you are the official wedding photographer, then it is your job to ensure the quality of the resulting portfolio of pictures. Sometimes, therefore, you need to take a hand and direct the subjects if, in your judgment, better photographs will result.

Although much of the coverage of a wedding consists of semi-candid images (the guests milling about outside waiting for the bride's arrival or the groom and best man checking their watches nervously) and a series of traditional set-piece shots (the bride arriving at the ceremony, for example, walking down the aisle on her father's arm, and, as here, the couple kissing as they leave the church porch), there is still much scope for creative and imaginative pictures.

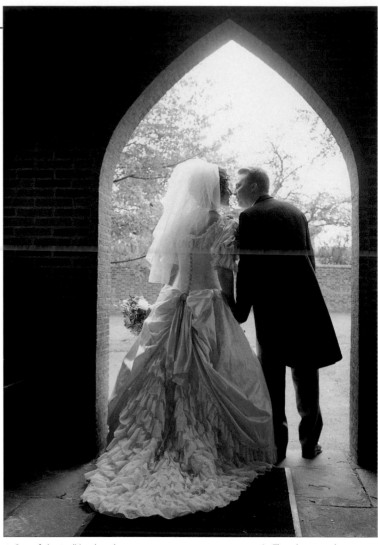

Hints and tips

● Keep at least part of your attention on what is happening on the periphery of the scenes you are photographing. This way, you may be able to include some extra element that lifts your images out of the ordinary.

● As a wedding photographer, you need to develop sufficient self-confidence to be able to position and direct your subjects in order to take the best possible photographs.

▲ One of the traditional wedding shots is of the bride and groom pausing in the church porch to kiss. Most often, however, this image is taken from the front, with the couple seen against a background of the shadowy interior of the building. A nice variation, therefore, is this image, which has been taken as if it were a candid shot, of the couple viewed from behind.

PHOTOGRAPHER:
Nigel Harper

CAMERA:
35mm

LENS:
50mm

EXPOSURE:
⅟₁₂₅ second at f8

LIGHTING:
Daylight only

▶ There is no one best way to take a picture, and for this version the photographer has moved back a little so that the lens takes in the attractive rough-hewn wooden archway, making a frame within a frame, and the old timbered ceiling and cast-iron light fitting in the church porch. These features alone add extra information, atmosphere, and an enhanced three-dimensional quality. However, the photographer also directed the page boy to enter the frame. The direction of his gaze firmly anchors the couple centre stage.

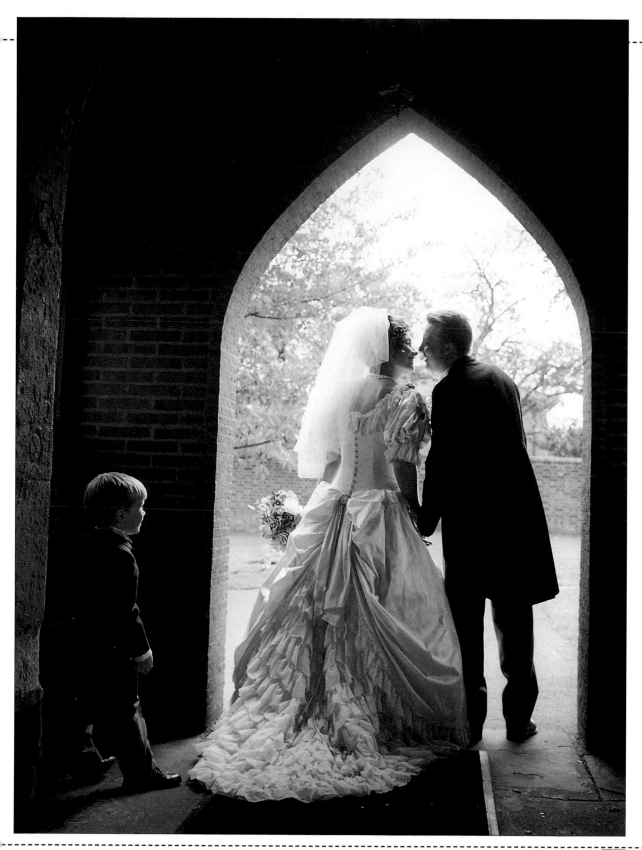

FRAMING FOR IMPACT

Directly after the ceremony, when the bride and groom have emerged from the church, there is often an almost tangible release of tension. For the leading players, and the supporting cast of characters, the weeks of planning and worrying are at last over; for the invited family and friends, the most restrained part of the proceedings are behind them and, like a long-held breath, they can now relax, loosen overtight clothing a little, and look forward to the party to come.

It is at this point that you, as photographer, will really appreciate any preplanning you have carried out. The time and place of the ceremony have been known well in advance – so, weather permitting, you should have a pretty clear idea of where the light will be best around the church building and grounds for the first of the many set-piece shots that will be required of you throughout the rest of the day.

PHOTOGRAPHER:
Trevor Godfree

CAMERA:
35mm

LENS:
210mm

EXPOSURE:
⅟₆₀ second at f8

LIGHTING:
Daylight only

▶ *The framing of this close-up is perfect of its type. The faces of the couple completely fill the frame (excluding any possibility of a distracting background), the lighting is bright and revealing without being harsh or unflattering, the kiss on the cheek is tender, and the bride looks radiant as she gazes directly into the camera lens.*

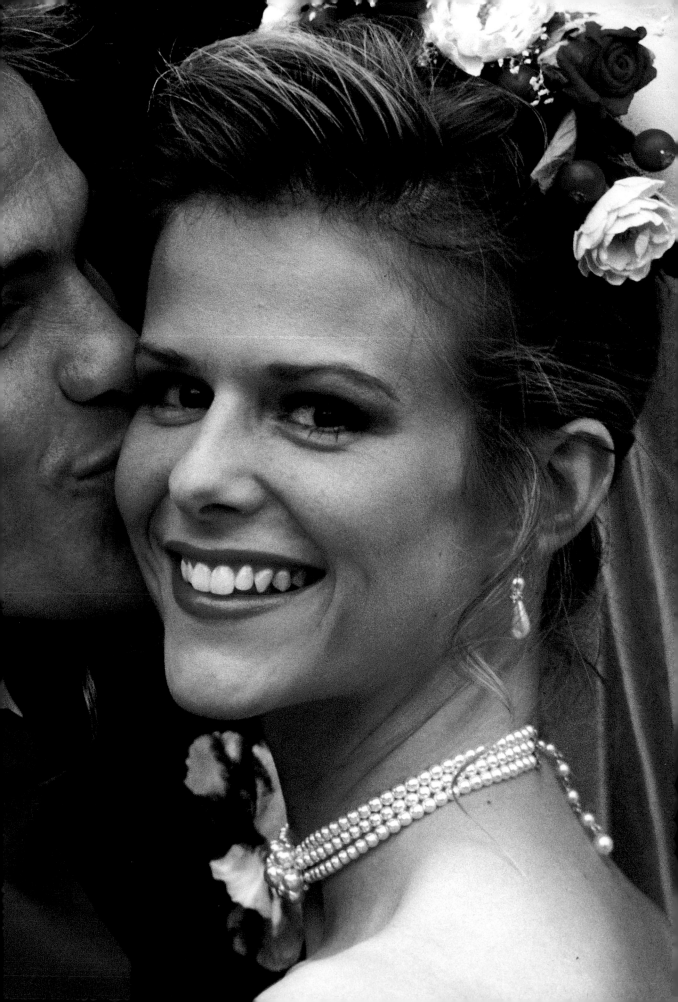

Bear in mind that the newlyweds still have a difficult role to play. They are the centre of a great many people's attention and there are many demands on them to greet family and friends, to circulate, to be part of this group or that. You will have to be firm, yet diplomatic, in order to get the couple quickly into the various spots you should have pre-selected for the different shots.

▶ *Every wedding album will benefit from a thoughtful range of differently framed photographs. In this shot of the couple, an earlier visit to the church grounds by the photographer determined that this background of shrubby foliage would be ideally lit at about the projected time for the end of the ceremony. It is this type of planning that can make the difference between one set of pictures that simply "does the job" and another set that makes the day look like it was a magical event.*

PHOTOGRAPHER:
Trevor Godfree

CAMERA:
35mm

LENS:
105mm

EXPOSURE:
$\frac{1}{125}$ second at f11

LIGHTING:
Daylight only

▲ *A part of the preplanning exercise the wedding photographer should carry out before the wedding day involves visiting the location where the ceremony is to take place. This need take only a few minutes of your time, but it will allow you to see where the strengths and weaknesses of the venue lie and where the sun will be on the "big day" so that you can plan your set-piece photographs – those inside the building as well those outside in the grounds.*

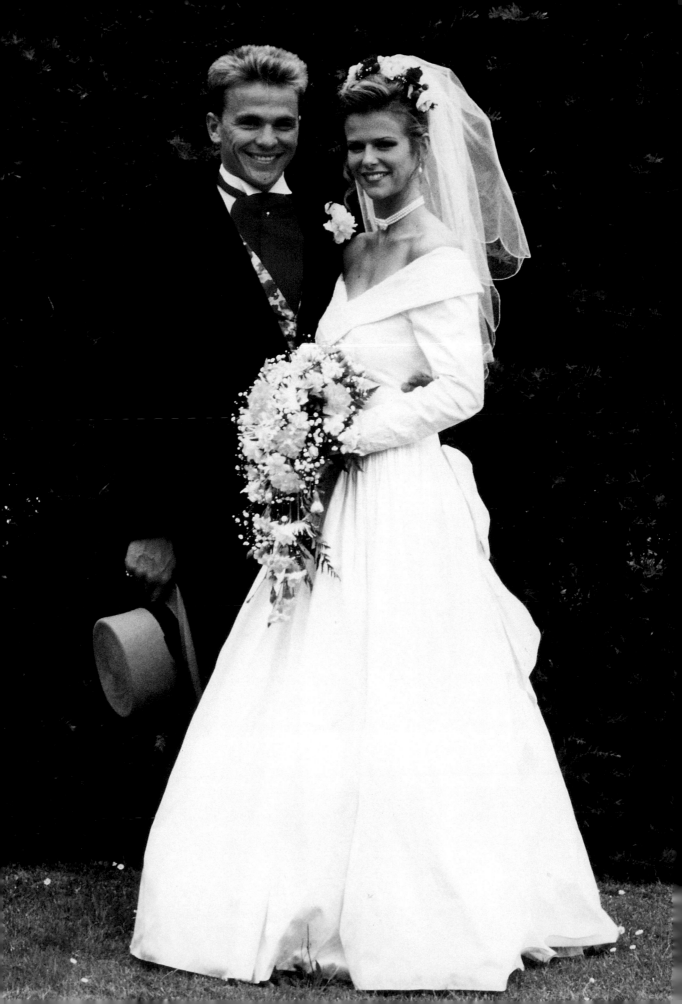

COLOUR OR BLACK AND WHITE?

The debate concerning the relative merits of colour versus black and white has been going on since colour film first became widely available about 30 years ago. A minority of photographers work happily in both mediums, but most photographers prefer to specialize in either one or the other. As the two excellent pictures presented here illustrate, however, both black and white and colour are eminently suitable for recording a wedding portfolio – it basically comes down to a question of personal preference.

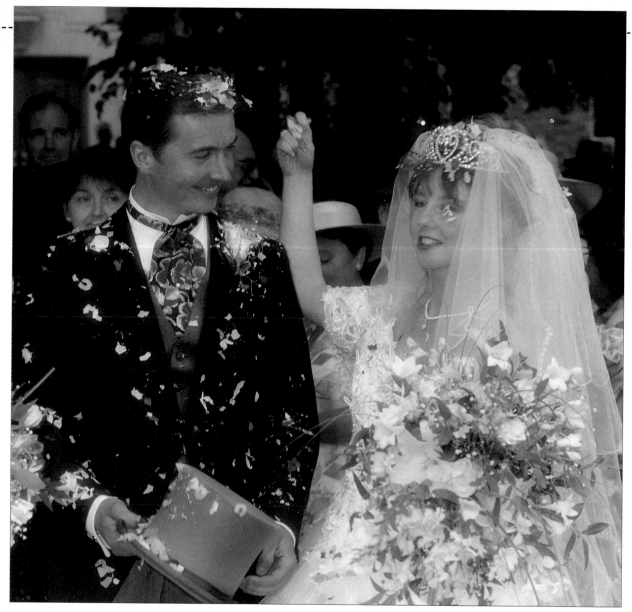

▲ Sharing this happy moment, the bride catches a handful of confetti to add to the growing pile on her husband's head.

PHOTOGRAPHER:
Richard Dawkins

CAMERA:
35mm

LENS:
35mm

EXPOSURE:
⅟₅₀₀ second at f5.6

LIGHTING:
Daylight only

◀ Leaving the registry office, these newlyweds look radiantly happy as the confetti rains down on them.

PHOTOGRAPHER:
Mandi Robson

CAMERA:
6 x 6cm

LENS:
120mm

EXPOSURE:
⅟₁₂₅ second at f8

LIGHTING:
Daylight supplemented by flash

WIDE-ANGLE VIEWS

Although the majority of pictures making up a typical wedding portfolio will be taken by lenses with focal lengths ranging from standard (50mm on a 35mm camera) through to moderate telephoto (about 135 or 150mm on a 35mm camera), there are times when the wider angles of view of shorter focal lengths are necessary.

The principal advantage of using a telephoto is that you can fill the frame with the subjects without having to move in too close. Stemming from this, it is therefore possible to take more candid, informal images because subjects are less likely to be aware of your presence. However, when you want to show the setting of an event, such as a wedding, or you need to encompass a large group of people, your best choice of lens is a wide-angle.

▶ In order to show the church, thronging guests, the bridal couple themselves and the flying confetti, the tartan-clad piper, and the ceremonial Rolls Royce, the photographer used a wide-angle lens. If he had been shooting from the same camera position using a 135mm telephoto on a 35mm camera, the photographer could have taken a close-up portrait of the bride and groom alone.

PHOTOGRAPHER:
Hugh Nicholas

CAMERA:
35mm

LENS:
28mm

EXPOSURE:
1/250 second at f8

LIGHTING:
Daylight only

Wide-angles and camera formats

When you classify lenses as wide-angle, standard, or telephoto, you have to remember that the specific focal lengths you assign to these categories depend on the format of the camera. The two most popular camera formats are 35mm and medium format – either 6 x 6cm or 6 x 7cm. The image area of a 35mm negative is considerably smaller than that of a medium-format camera, and wide-angle lenses start at about 45mm Wide-angle focal lengths for medium format cameras start at about 65mm. For comparative purposes, a standard lens on a 35mm camera is about 50mm, while a standard lens on a medium format camera is about 75mm.

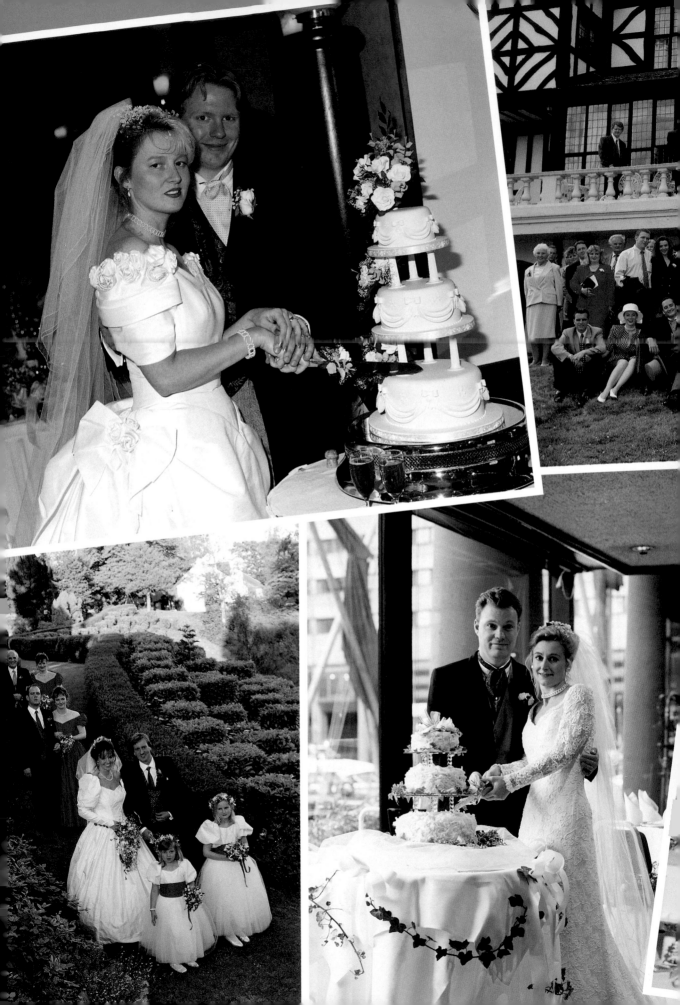

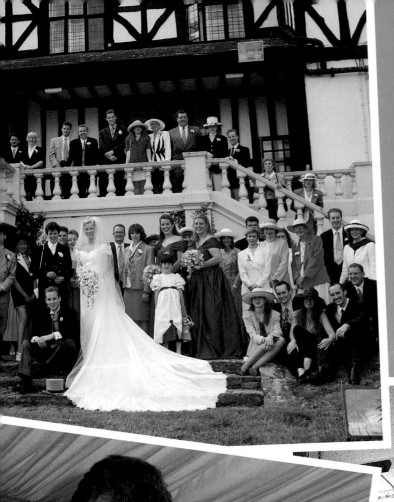

THE
RECEPTION

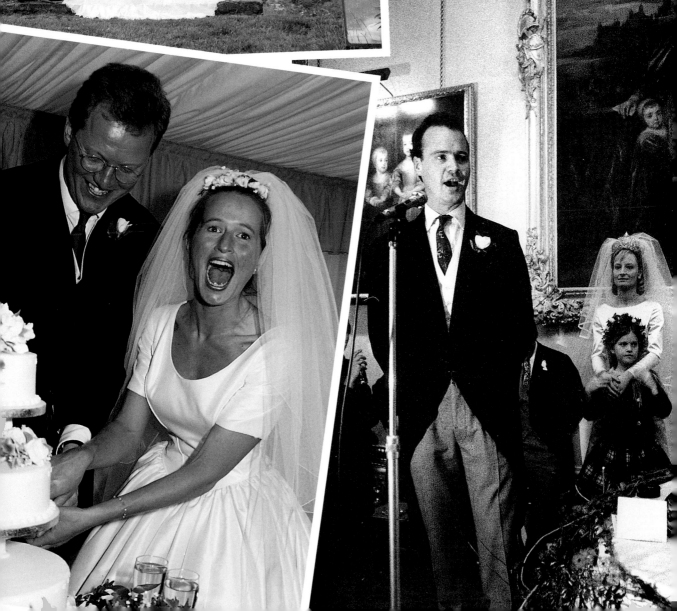

CREATIVE SHUTTER SPEED

The majority of wedding photographs are taken at shutter speeds that allow the camera to be safely hand held without the danger of camera shake or subject movement intruding and "spoiling" the image – approximately in the range of $\frac{1}{125}$ second up to the fastest shutter speed offered on the camera. But by experimenting with other shutter speeds you can create some extremely unusual and eye-catching effects. Obviously, techniques such as the one employed here, can be used only occasionally in the context of producing a portfolio of wedding photographs.

PHOTOGRAPHER:
Nigel Harper

CAMERA:
6 x 6cm

LENS:
120mm

EXPOSURE:
3 seconds at f16

LIGHTING:
Flash and tungsten

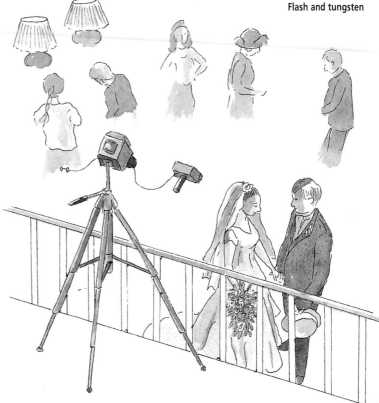

Hints and tips

To produce a photograph of the type shown here, follow these steps:

● Set the camera up on a tripod where you have an unobscured view of the subjects.

● Select a shutter speed of about 3 full seconds (or manually time a 3-second exposure if necessary).

● Use a cable release to trip the shutter and, as soon as the exposure starts, fire a flash directed just at the subjects.

● Brief the subjects beforehand so that they know they must stand completely still throughout the entire exposure.

● While the shutter remains open for the full 3 seconds, the people swirling about and dancing will record on the film as impressionistic streaks and blurs.

▶ *The length of the exposure needed to create an effect such as this depends on how quickly the people are moving past and around the stationary couple in the centre. The quicker they are moving, the briefer the exposure needed. This is obviously an experimental technique, however, so try a series of exposure ranging from, say, 2 seconds up to 5 or even 6 seconds, and then select the best one after processing and printing. You will need a camera with a shutter speed that can be set for multiple seconds (or one that can be held open for a manually timed exposure); a tripod (or some other firm camera support); a cable release to trip the shutter; and a flash. Some of the figures in the background are reasonably sharp due to the fact that they were sitting down and barely moving throughout the exposure.*

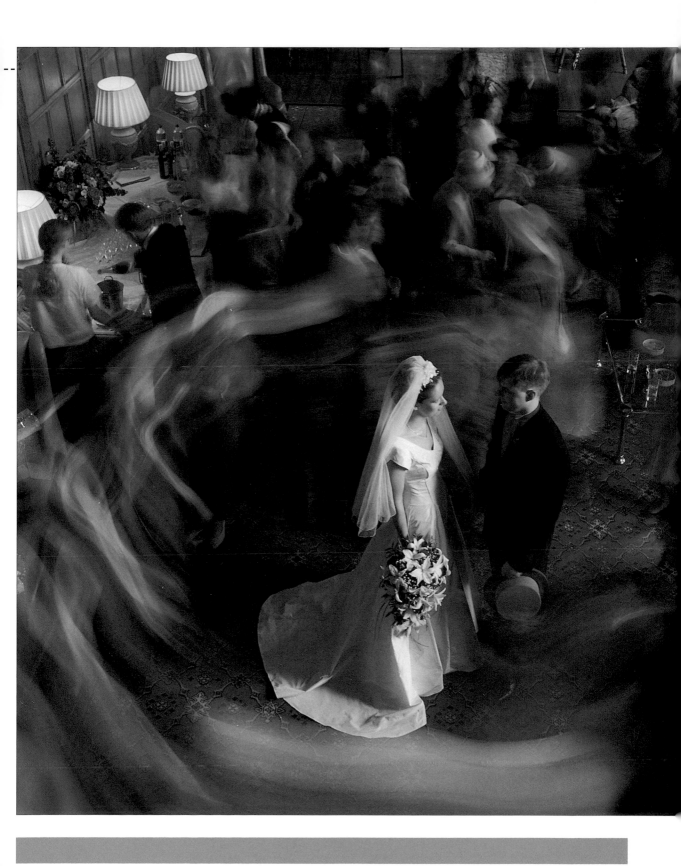

"CAN'T BE MISSED" SHOTS

If you were to ask people to make a short list of the highlights of a wedding reception a photographer had to cover – shots that really can't be missed – coming somewhere near the top of the list would be the speeches from the head table and cutting the cake.

The speeches ceremony is, by definition, one of the least action-packed phases of the entire affair, but from the newlyweds' point of view, it must form part of their picture portfolio because all of the most central characters are present at the same table – parents and other members of the immediate families, best man, close friends, and so on. The challenge from the photographer's point of view is to somehow record the speeches in a lively and entertaining fashion. Traditionally, the speeches are used partly to thank those who have helped in the planning and preparation of the wedding, and also those of the supporting cast who actually participated in it. However, part of the tradition also involves a certain amount of humour, usually by relating publicly some anecdote or event that the subject of the speech would rather have remained private. These are the moments you need to listen out for, since it is precisely then that the facial expressions of those listening, and of the person being publicly embarrassed, make the best photographs.

The cake-cutting part of the reception, as recorded by the photographer, is almost always set up specifically for the camera. At some point during the party, the bride and groom will be extracted from the throng and asked to pose by the cake, with both their hands on the knife handle, while the photographer takes a few photographs. Because it is a set-piece shot, the photographer should coach the subjects through it, asking them to adjust their positions to improve the composition, to look at the camera, or at each other. Talking to the couple throughout is a good way of getting them to relax and to react, and thus stop them going "wooden", and this maximizes your chances of producing an entertaining photograph.

PHOTOGRAPHER:
Richard Dawkins

CAMERA:
35mm

LENS:
105mm

EXPOSURE:
$\frac{1}{25}$ second at f8

LIGHTING:
Portable flash

▶ *The composition of this wedding reception speech is thoughtful and considered. A moderate telephoto lens was used to fill the frame from the body of the reception hall and the photographer has checked the viewfinder frame to ensure that all visible subjects are contributing to the atmosphere of the shot. The expression of the groom delivering the speech is natural and the attention being given to what he has to say, and its obviously amusing content, is evident in the faces of the people listening.*

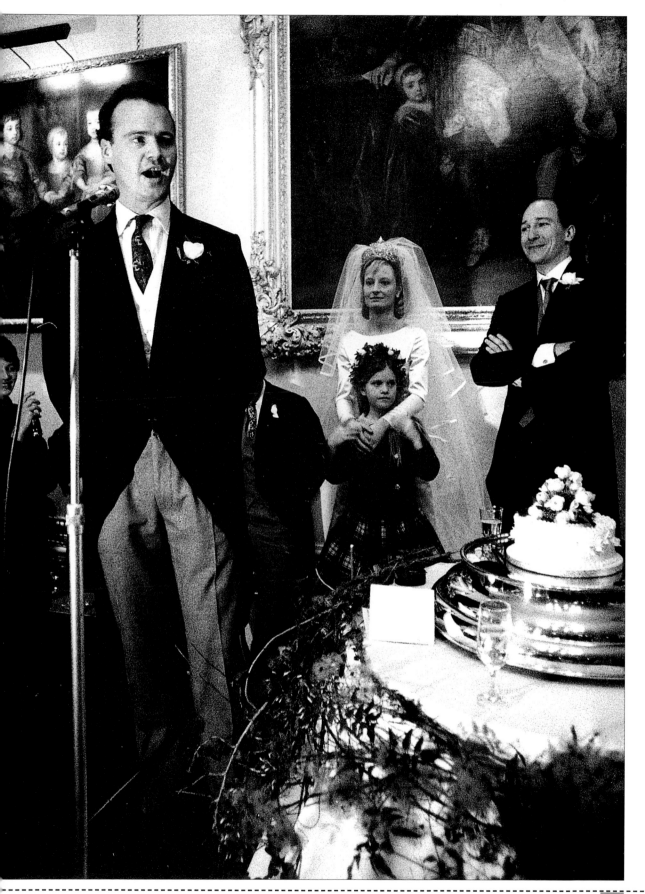

▶ *The photographer's timing for this image of the head table is near perfection. The groom has obviously just revealed in his speech something amusing about the woman dressed in red on the extreme left of the frame, and every face is laughing and turning in her direction, while she looks suitably embarrassed. From the angle the picture was taken you can imagine where the photographer was standing, and it is evident that as you look down the table there is a subtle change in overall colour, with the image becoming increasingly "warm" looking. This is due to what is referred to as flash fall-off (see below).*

FLASH FALL-OFF

The light output from a flash gives consistent colour results for subjects positioned between a minimum and maximum distance from the flash. Anything positioned too close will be overexposed and subjects beyond the maximum range will become progressively underexposed. This is known as flash fall-off. In this diagram you can see that the angle of the flash has recorded the subjects as far as the groom well, with whites looking white and skin tones looking natural. Beyond the groom, however, the power of the flash has diminished and tungsten room lighting can be seen to be having more of an effect. Tungsten lighting is deficient in the blue part of the colour spectrum and so anything recorded by it takes on an orange colour cast.

PHOTOGRAPHER:
Nigel Harper

CAMERA:
35mm

LENS:
28mm

EXPOSURE:
⅟₆₀ second at f5.6

LIGHTING:
Portable flash

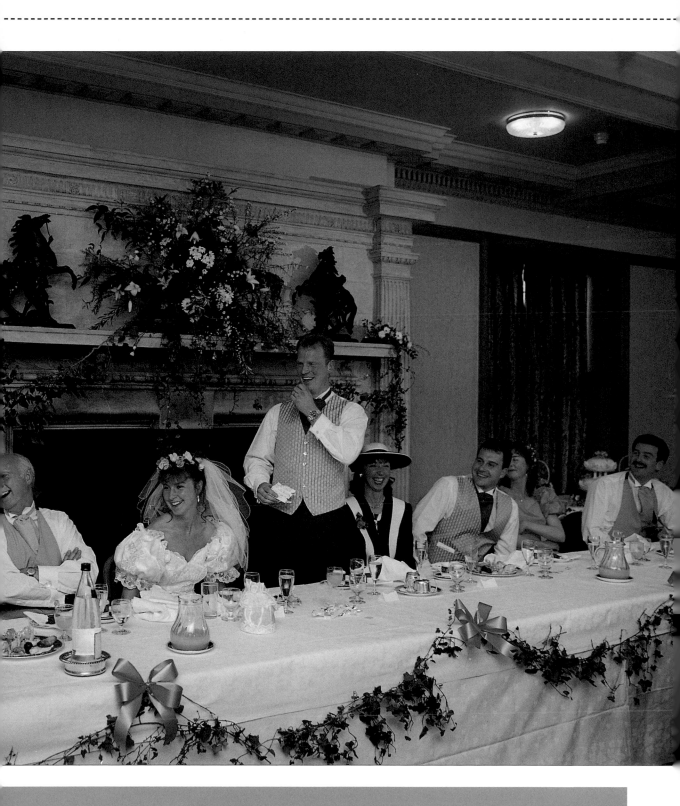

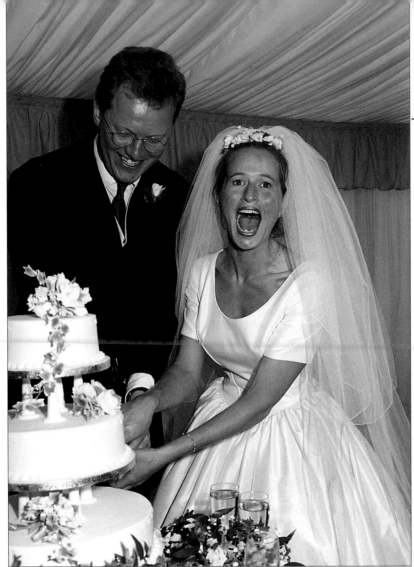

◄ The photographer's coaching was vital to the success of this picture. While the shot was being set up and arranged, the photographer constantly talked to the subjects, finally eliciting this joyful expression from the bride just as the shutter release was pressed.

PHOTOGRAPHER:
Philip Durell

CAMERA:
35mm

LENS:
75mm

EXPOSURE:
½₂₅₀ second at f8

LIGHTING:
Portable flash

▶ The wedding cake is often elaborate and has to be a feature. This picture has all the elements of a good shot – the newlyweds with their hands on the handle of the knife and the wine glasses in the foreground symbolizing their union.

PHOTOGRAPHER:
Hugh Nicholas

CAMERA:
6 x 7cm

LENS:
80mm

EXPOSURE:
½₂₅ second at f5.6

LIGHTING:
Portable flash

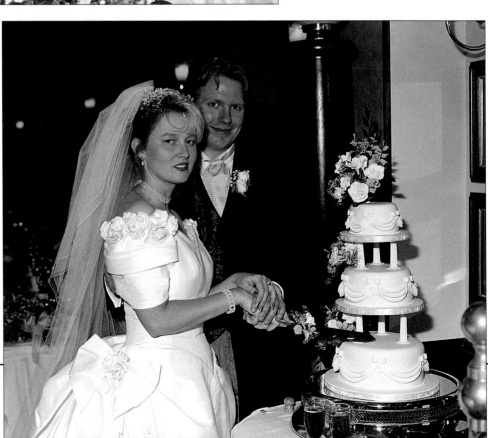

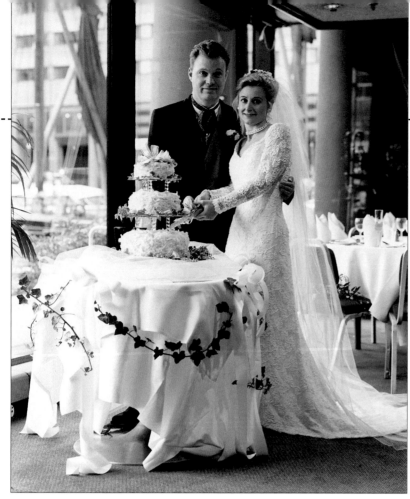

◄▼ *Whether the image is sharp and crisply detailed or more interpretative in its treatment, with some of the detail sacrificed to create more of a soft and romantic type of image, is largely a matter of personal taste. Here, the photographer has covered himself by taking two version of the same scene, incorporating a slight change of pose. In one he used no special effects filter on the lens, while in the second he used a diffusion filter – which is also known as a soft-focus filter.*

PHOTOGRAPHER:
Hugh Nicholas

CAMERA:
6 x 7cm

LENS:
105mm

EXPOSURE:
⅟₁₂₅ second at f8

LIGHTING:
Daylight supplemented by flash

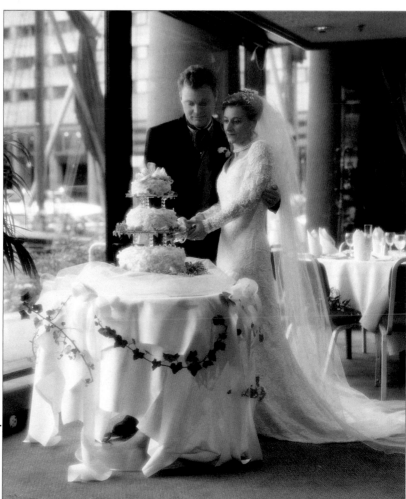

PICTURE FORMATS

When using a 35mm or medium-format camera, other than 6 x 6cm, you have the choice of framing your subjects with the camera held normally, to produce a horizontal-format picture (also known as "landscape" format) or, with it turned on its side, to produce a vertical-format picture (sometimes referred to as "portrait" format). As you would assume from the 6 x 6cm camera's name, it produces a square negative, and so it make no difference which way around you hold it.

Although it is generally more comfortable to hold the camera as if taking a horizontally framed picture, you should use the different types of framing available to you to help strengthen subject composition. Horizontally framed pictures, for example, tend to emphasize the flow of visual elements across the frame, while vertically framed shots help to strengthen the relationship between foreground and background picture elements. A square-format image tends to be neutral in this regard, but if you leave space at the top and bottom, or to the left and right of the subjects, you can crop the image at the printing stage to produce a horizontal or vertical image, depending on which suits the subject.

▶ In this picture, the photographer has used horizontal framing to good advantage in order to emphasize the visual flow of the subjects across the frame in an informal group portrait that was taken at a quiet moment during the wedding reception. Holding the camera the other way around would also have given undue prominence to the foreground area of grass.

PHOTOGRAPHER:
Mandi Robson

CAMERA:
6 x 6cm

LENS:
105mm

EXPOSURE:
1/125 second at f8

LIGHTING:
**Daylight supplemented
by flash**

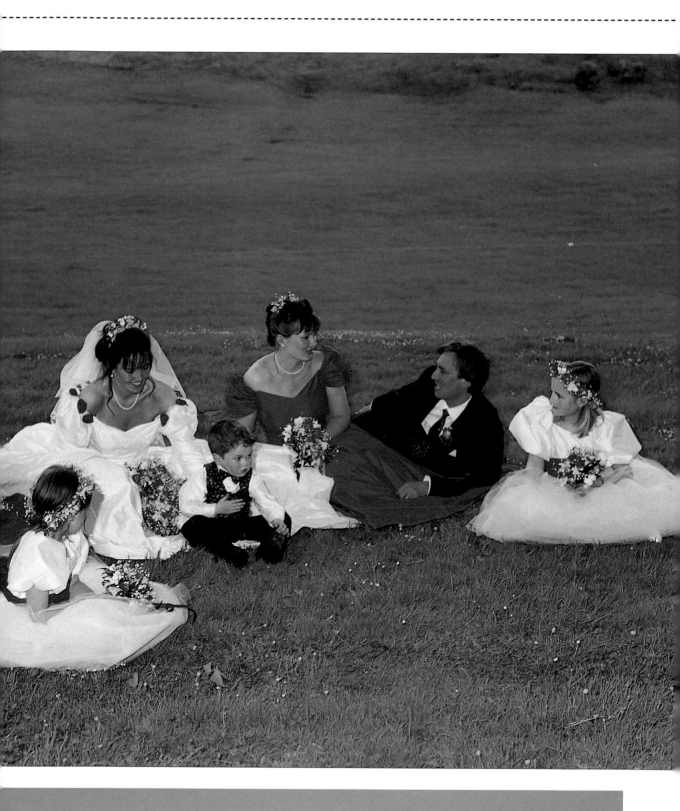

▲ Of all the picture formats available, the type of square image produced by a 6 x 6cm medium-format camera tends to be most neutral in the influence it has on subject matter. In this more formal portrait of the wedding party, the movement from front to back through the frame is very strong in any case, and thus works well as a square image. Note, however, that the photographer has left room at the sides of the subjects to allow for some cropping later on if necessary (see opposite).

PHOTOGRAPHER:
Mandi Robson
CAMERA:
35mm
LENS:
50mm
EXPOSURE:
$1/125$ second at f8
LIGHTING:
Daylight supplemented by flash

◀ By cropping some of the image either side of the procession, the photographer has turned a square-format image into a vertical one. The relationship between foreground and background subject elements was already strong, but this movement into the frame has been even further enhanced by this darkroom treatment.

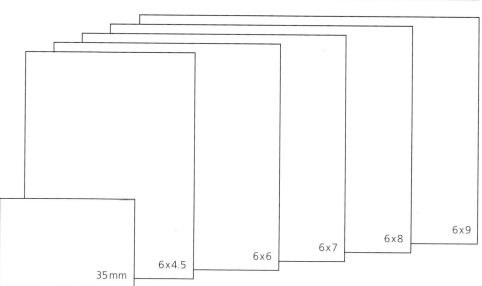

35mm

6x4.5

6x6

6x7

6x8

6x9

◀ All but the 6 x 6cm format produce a rectangular image, giving you the option of recording a vertical or a horizontal image, depending on which way around you hold the camera. All of the various 6cm-format cameras are known as medium format.

LARGE-GROUP PORTRAITS

At some stage of nearly every wedding reception the official photographer will be confronted with the sometimes daunting prospect of organizing and shooting a group photograph of the newlyweds, their immediate families, and all of their guests. This could involve arranging dozens of people at an average-sized wedding, all the way up to a hundred plus people at large affairs.

The most difficult setting you may find yourself in is when you (and the camera) are on flat ground at the same level as the members of the group. In this situation you have no option other than to rank people according to their height, much as in a school photograph, with the taller members of the group toward the rear and the shorter ones at the front. Associated with this solution are the disadvantages that you break up family groupings, and you also tend to find that most of the men are at the rear because they are taller and most of the women are at the front because they are shorter. But it may be the only way to organize the shot so that all their faces are visible. Even so, you will have an added margin of flexibility if you can gain just a little extra height – by standing on your camera case, for example, if it is sufficiently robust. Some photographers carry a lightweight aluminium stepladder in the back of the car for just such a situation.

PHOTOGRAPHER:
Nigel Harper

CAMERA:
6 x 7cm

LENS:
50mm

EXPOSURE:
⅟₆₀ second at f8

LIGHTING:
Daylight only

▶ *A sloping lawn set-in with steps leading to another flight of steps and a long balcony provided a good variety of levels on which to pose the members of this wedding party. The black and white Tudor-style façade of the reception venue is another attractive feature of the picture.*

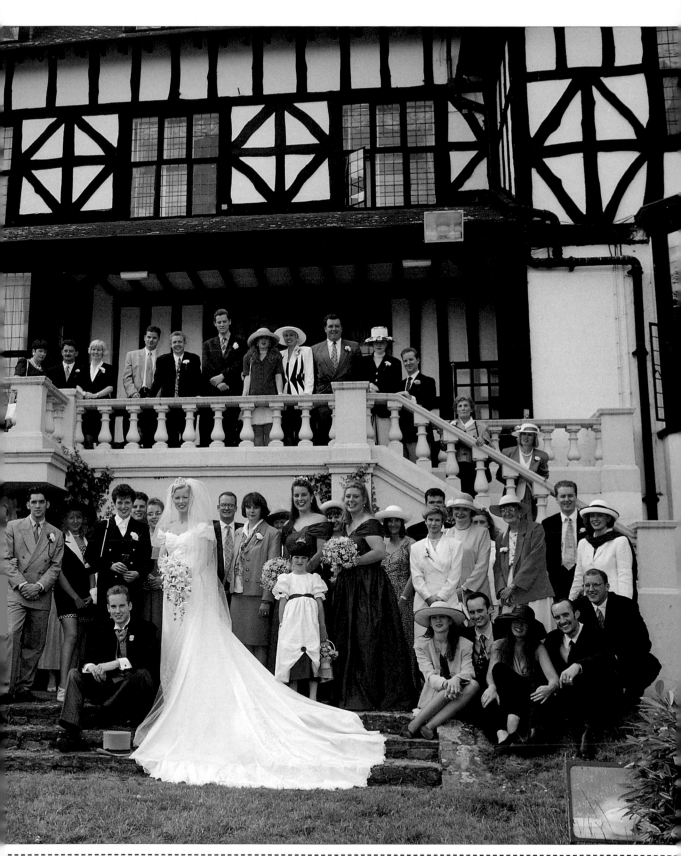

Large-group portraits become a lot easier to organize if the camera and the subjects are on distinctly different levels. If the reception venue has a series of steps – perhaps leading up from a lawn and then carrying on up to the front lobby area – then you can start being more creative in how you compose the shot. You may now, for example, be able to keep family groups together by ranking members of individual groups according to height and then positioning groups as a whole on different levels, while you stay down below and shoot up at them.

If, however, the venue does not offer you a series of steps to work with (or the light is not suitable), or the building itself is not particularly attractive on the outside and you don't want it visible in the picture, you may still be able to shoot from a different level – from a balcony or an upper floor window. This way, you will be above the group shooting down at their upturned faces.

No matter which solution is best in the circumstances you are confronting, it is a wise course of action to make three, four, or five exposures. While it is true that the faces of those at the back of the group will probably not be seen clearly enough for their facial expressions to matter much, those in the first few ranks of the group should be clear enough for a stifled yawn, half-blinking eyes, or a pulled face to spoil the shot – especially if it is one of the leading players or a member of the supporting cast.

PHOTOGRAPHER:
Nigel Harper

CAMERA:
35mm

LENS:
35mm

EXPOSURE:
$\frac{1}{125}$ second at f8

LIGHTING:
Daylight only

▲ *Space was tight either side of this group because of a car park and a public entrance to the building, so the photographer had to keep everybody close together. Changes of level were only slight as well, so people had to be ranked according to height. By using a moderate wide-angle lens off-centre to the group, a large expanse of uninteresting foreground was avoided.*

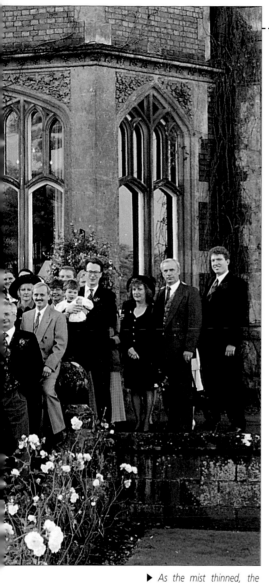

<div align="center"><i>Hints and tips</i></div>

● Portable flash is usually unsuitable for large-group portraits. The intensity of flash light falls off very quickly and there may be a noticeable difference in exposure between the front of the group closest to the flash and the rear of the group furthest from it.

● If extra light is necessary, try to position the group where it receives reflected light from a nearby wall or the side of a white-painted building somewhere out of shot.

● Work as quickly as you can when organizing a group portrait. It is difficult to keep everybody's attention and people will soon start drifting away or turning around to speak to friends.

● Mount the camera on a tripod with all the exposure controls set in advance. This way, you don't have to peer through the viewfinder all the time. It is easier to keep the group's attention if you can maintain eye contact with them.

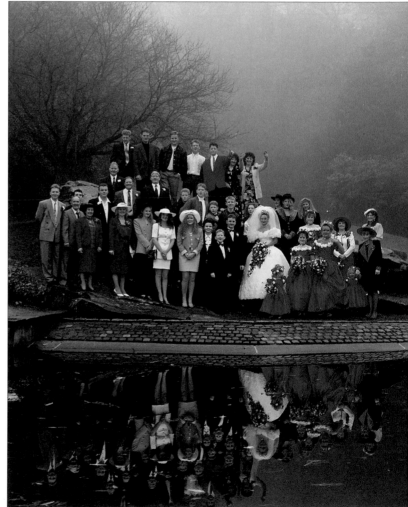

PHOTOGRAPHER:
Mandi Robson

CAMERA:
35mm

LENS:
85mm

EXPOSURE:
⅟₆₀ second at f11

LIGHTING:
Daylight only

▶ *As the mist thinned, the photographer quickly assembled the guests by the side of an ornamental pond, where she could take advantage of the reflections thrown back by the water. A variety of different levels was achieved by arranging people on the large boulders of a rockery. Luckily, most of the guests were wearing bright, strongly coloured clothing, which, when combined with the background mist, gives this photograph an almost theatrical quality.*

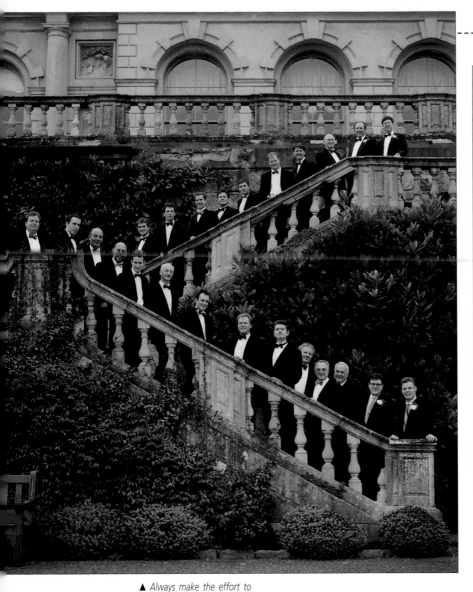

Which lens?

If the general conditions are cramped and you can't distance yourself much from the group, then you will have little option other than to use a wide-angle lens. On the popular 35mm camera format, a useful focal length is a 35mm wide-angle. A 28mm wide-angle is also suitable if it is a good-quality lens and free from distortion at the edges. Anything wider than 28mm is likely to show distortion as well as make the figures so small in the frame individual faces may hardly be discernible. Unless you are extremely close to the group, a wide-angle lens will tend to encompass a lot of the foreground between the camera and the subjects. If necessary, this can be cropped off during printing.

If you have plenty of free space to move back away from the group, then you may find that a moderate telephoto lens is a better bet – a lens of about 70-85mm for the 35mm camera format. These moderate telephotos are sometimes called portrait lenses because of the flattering effect they have on facial features, but their more restricted angle of view means they have to be used from further back for large groups.

▲ *Always make the effort to introduce a little humour into your photography if possible – weddings shouldn't be desperately serious affairs after all. Here the photographer has seen the light-hearted potential offered by this flight of steps, and has arranged one dinner-suited guest on each step. The effect is a little like seeing a parade of penguins, which, by the expressions on some of the faces, is a thought that had also occurred to those involved in the shot.*

PHOTOGRAPHER:
Nigel Harper

CAMERA:
6 x 7cm

LENS:
75mm

EXPOSURE:
⅟₆₀ second at f16

LIGHTING:
Daylight only

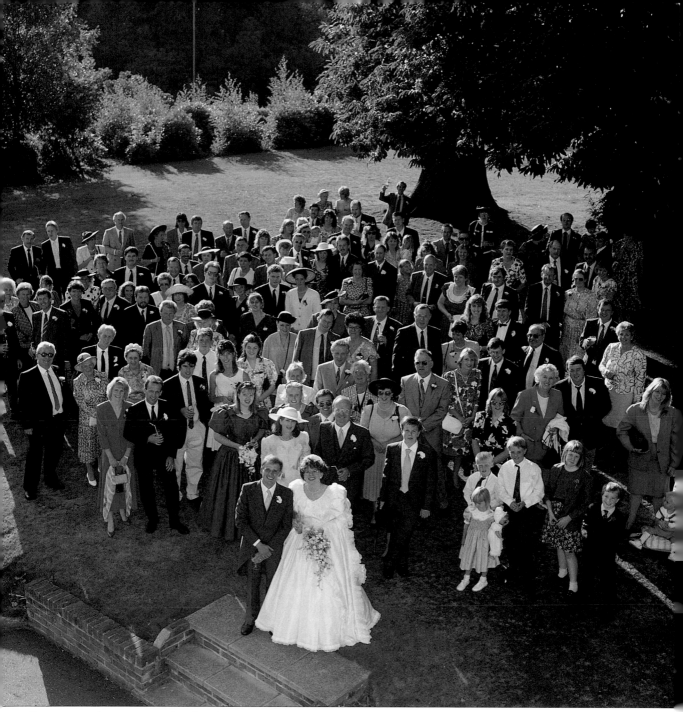

▲ The most appropriate way to organize the large-group portrait at this wedding reception was to allow people to come together in a loose group on the sun-lit lawn and then to take the picture from an upstairs window. Everybody seems happily relaxed and every face is clearly visible. However, do take care – if the window you shoot from is too high up, then people will have to bend their necks at an uncomfortable-looking angle in order to look at the camera.

PHOTOGRAPHER:
Trevor Godfree

CAMERA:
6 x 6cm

LENS:
85mm

EXPOSURE:
1/500 second at f11

LIGHTING:
Daylight only

THE FIRST DANCE

One of the rituals commonly observed at the wedding reception is the bride and groom taking to the floor for the first dance. If you have discussed the form the celebrations will take with the bride and groom before the ceremony, you will know in good time about detail such as this, and so you can be ready in position beforehand. You need to keep your wits about you at the reception and be sensitive to how the activities are progressing. Bear in mind that this is the newlyweds' occasion and you are there to, largely, record it as it happens. By asking the couple to go back and do it again because you were not ready, you are likely to miss out on capturing the spontaneity of the event. You may get the picture, but the expressions on the onlookers' faces will probably reveal the cheat.

PHOTOGRAPHER:
Nigel Harper

CAMERA:
35mm

LENS:
24mm

EXPOSURE:
¹⁄₁₂₅ second at f5.6

LIGHTING:
Daylight only

▲ *The many people working behind the scenes are a vital component of a successful wedding celebration. Here, the photographer has turned his camera on the string quartet* *playing just out of sight of the main reception area. His foreground framing to include a topper and ladies' bonnets is a clever visual link to the celebrations in the next room.*

▶ *Strong directional sunlight flooding into the reception venue throws hard-edged shadows onto the dance floor in front of the newlyweds. Lighting such as this creates a high-contrast image, which is extremely suitable for the black* *and white medium. By using a fast film (ISO1600), the photographer had extra flexibility with his exposure settings, since he was able to choose a fast shutter speed to freeze subject movement and a small aperture for additional depth of field.*

PHOTOGRAPHER:
Nigel Harper

CAMERA:
35mm

LENS:
24mm

EXPOSURE:
¹⁄₁₂₅ second at f8

LIGHTING:
Daylight only

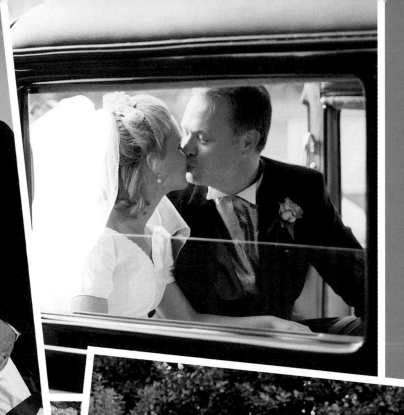

PORTFOLIOS

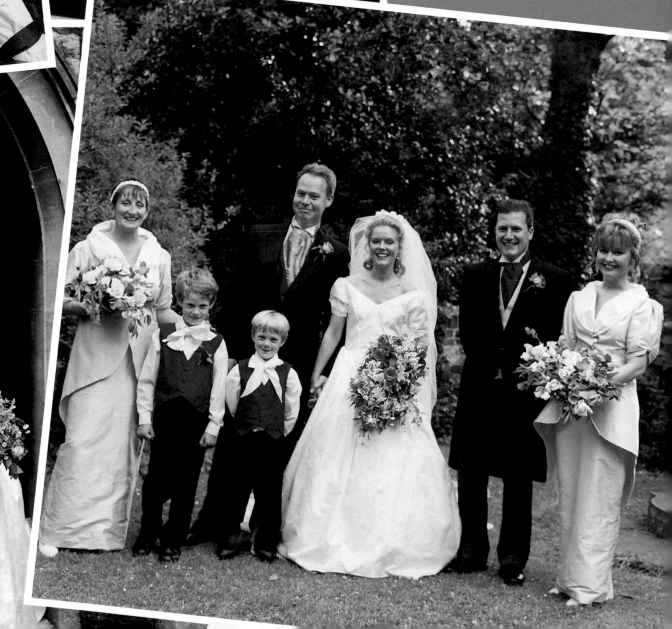

Jos Sprangers

Commissioned portfolio of photographs of a civil wedding ceremony. Coverage started on the morning of the wedding service, a few hours before the actual ceremony. The season was early summer and the weather was settled and set fair. The style of the wedding was very informal and the clients wanted this relaxed atmosphere to be reflected in the photography as well. Therefore, most of the pictures of the leading players and the supporting cast, in this case the two young flowergirls, were taken outdoors in a large public garden. Where indoor shots were taken, Jos decided to stay with daylight as the principal light source, again for its natural qualities. Wherever possible, Jos's instructions to the subjects about the poses they should adopt were kept to a minimum and, as a result, the pictures throughout have a semi-candid quality.

▲ The bride with one of her flowergirls. Selective focus and a large aperture has been used to record them sharply while showing the groom and the second flowergirl rendered more softly in the background.

Before the ceremony
To take advantage of the summer sunshine, and to avoid the formality of a studio setting, a large public garden was the setting for a short photography session on the morning before the wedding ceremony. The bride and groom were very definite about the style of pictures they wanted taken, something that can make the photographer's job a lot easier.

▶ Relaxing under the shade of a tree, using the leaf canopy to interrupt some of the direct rays of the sun.

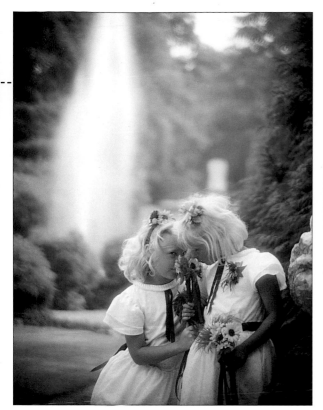

▲ One of the colour themes running through this wedding is yellow, which is established in this picture of the flowergirls in secret conversation, hiding their mouths behind the summer yellow of sunflowers.

▼ A similar technique was used here of the groom bending to kiss his wife to be, but the power of the flash was reduced to create a more dramatically lit image.

▲ A change of pace is represented by this close-up detail of the bride's unusual bouquet draped over the knees of a garden statue. A long lens and a wide aperture ensured that only the foreground detail was sharply recorded.

The ceremony

This part of the typical wedding coverage is most often dictated by the laid-down procedures of the ceremony. There were other photographers covering this wedding, including a videographer, and so, in a spirit of co-operation, all of the photographers agreed in advance their shooting positions so that nobody spoiled the shots of the others.

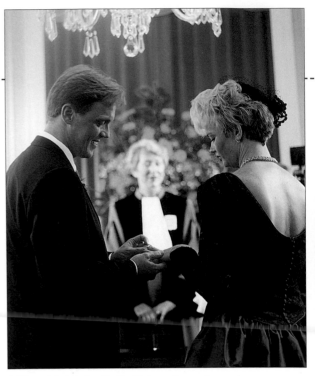

▲ Using a telephoto lens "looking" between the couple proved to be the perfect way to show the wedding ring being slipped onto the bride's finger. Manual focusing was necessary to prevent the camera's automatics locking onto the official standing in the centre of the frame in the background.

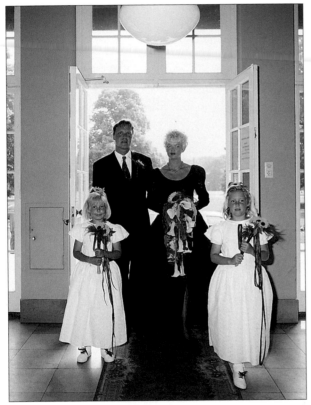

▲ Entering the registry office led by the two flowergirls. Although the lobby area was generally well illuminated with window light, this light was principally coming from behind the subjects. Thus, some supplementary flash was needed to show everybody's face clearly.

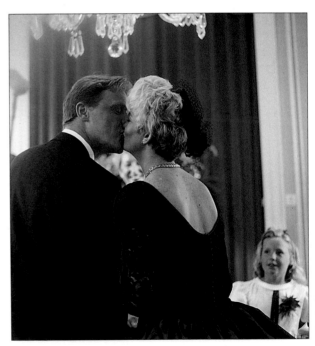

▲ A slight change of camera position brought the young flowergirl into the frame, looking up at the newlyweds as they kiss at the conclusion of the ceremony.

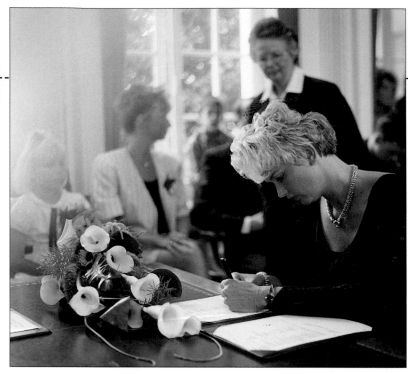

◄▼ *Photographs of the couple signing the marriage register after the ceremony are standard images and no portfolio would be complete without it being recorded from a few different angles.*

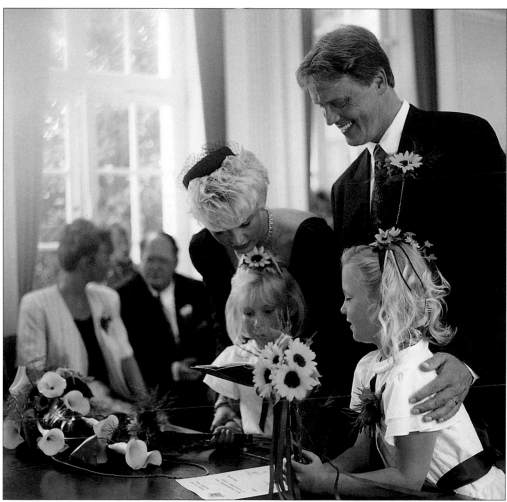

After the ceremony

At some stage during the day, you need to take photographs featuring all those who attended the wedding. This way you can guarantee that nobody is missing entirely from the coverage, which could be disappointing. Often, photographers are not employed to cover the reception, but you can still take a set-piece picture showing the couple with knife poised above the cake as if they were about to cut it.

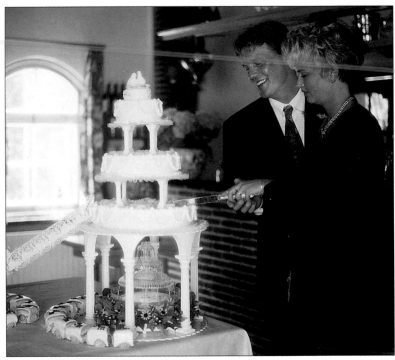

▲ Even if the reception is not being covered from start to finish, this type of picture can be set up and taken before the actual wedding.

▶ On the steps of the registry office after the wedding ceremony. The newlyweds are centre frame, and practically every face is turned in their direction as they kiss.

MAJKEN KRUSE

Commissioned portfolio of photographs of a formal church white wedding. Time was found a few days before the ceremony for a photographic session with the bride, in line with a detailed picture checklist that had been agreed with the clients. Majken finds that a picture checklist is a great advantage in helping to structure her time in the run up to the wedding and on the big day itself. There is no reason to think that because you know in advance the type and style of photographs wanted that your creativity is in any way stifled – it is still up to you to find the right angles, the best lighting, the appropriate lens, and the most telling moment to press the shutter release.

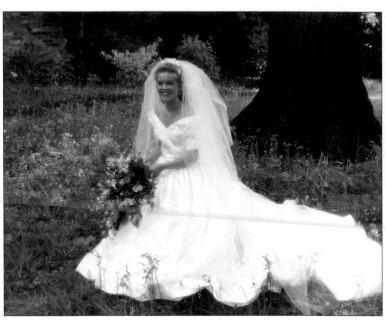

▲ A field of bluebells in an enclosed garden was the romantic setting for this picture. Although daylight was adequate, Majken used flash directed at the gown to prevent a potential colour cast from the foliage above.

Before the ceremony

The couple could not be photographed together before their wedding because the bride did not want the groom to see the wedding gown in advance of the ceremony.

▲ On the day of the wedding outside the church, the groom and his best man pose for a double portrait before the bride's arrival.

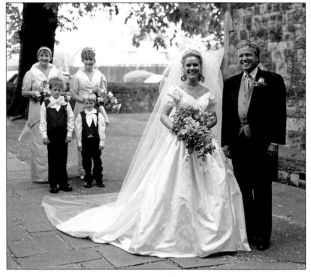

▲ The bride arrives at the church with her father. This formal grouping shows the bridesmaids and pageboys in the background, just slightly out of focus so as not to compete with the foreground subjects.

The ceremony

Majken had checked in advance that there was no objection to photographs being taken during the wedding ceremony itself and she knew exactly where she had to be and when to capture the best highlights of the proceedings.

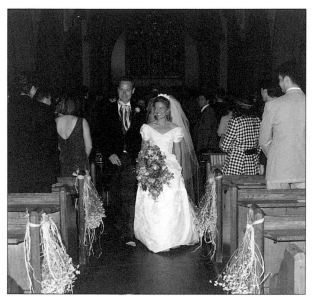

▲ The newlyweds walking up the aisle as man and wife. Both their expressions are wonderful.

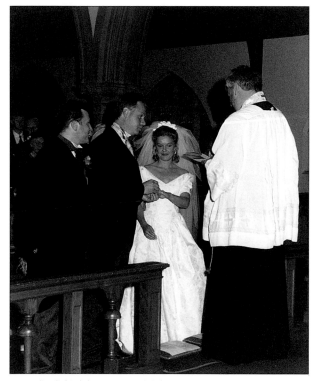

▲ Standing behind the priest provided this excellent shot of the ring being slipped onto the bride's finger. Light levels were very low and so flash had to be used.

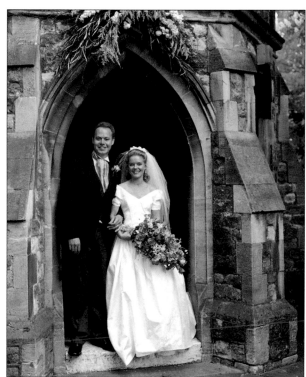

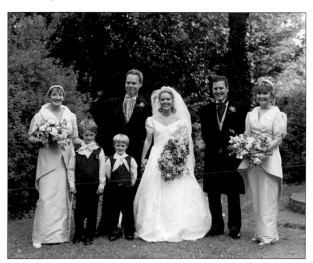

◀▲ In line with the prearranged shot list, the couple posed with the bridesmaids, best man, and pageboys. Then the newlyweds posed in the church porch, allowing Majken and all the guests with cameras to take this type of traditional portrait.

After the ceremony

If the transport provided to ferry the couple from the wedding to the reception is particularly photogenic, then make sure it features in your coverage.

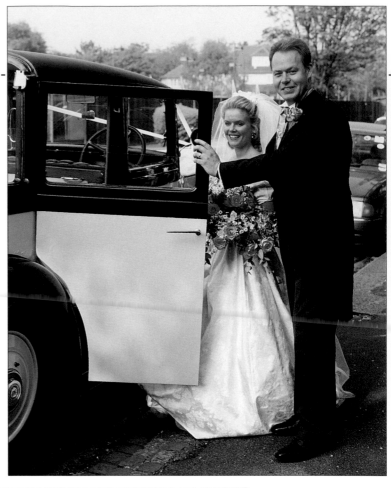

▶ ▼ *The vehicle used by the couple on their wedding day was a magnificent vintage Rolls Royce. Its large windows allowed a good view inside for a picture of the groom kissing his new wife.*

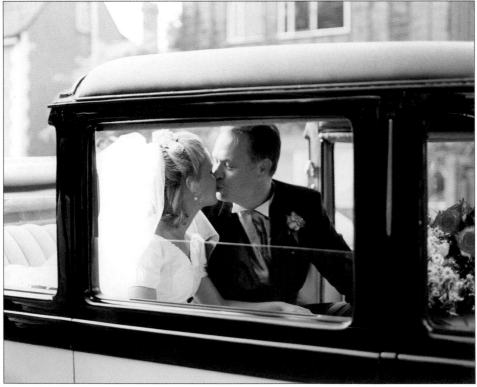

▲ The venue for the reception was a large, extremely ornate Victorian conservatory. The first picture at this location is of the couple, hand in hand, at the doorway with a tantalizing glimpse of the room beyond.

◀▲ The next image is of the interior of the conservatory itself, first taken with a wide-angle lens to show the entire area, and then next with a standard lens to bring up the detail of the table settings.

HUGH NICHOLAS

A portfolio of photographs of a church white wedding. Although there were elements of formality about the wedding, the attitude of the couple was orientated to it being a fun day, and this comes through very strongly in the pictures. The couple also wanted a mixture of colour and black and white photographs. In a situation such as this, it is better to have two cameras – one loaded with colour and the other with black and white. Although you can change film partway through a roll with many medium format cameras, it is still time consuming.

The ceremony

Photography was not allowed during the ceremony and so this part of the portfolio picks up on the couple as they are signing the register.

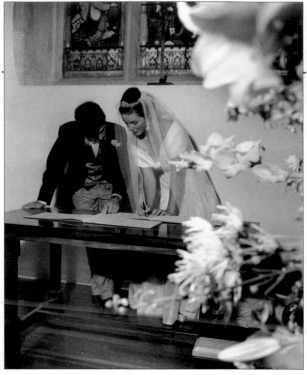

▲ The decision about which shots should be in colour and which in black and white was left to Hugh. This picture was taken with available light and the black and white film had a faster emulsion.

After the ceremony

Sometimes the hardest job a wedding photographer faces is getting the subjects to relax and look as if they are enjoying themselves. Hugh had no such problems at this wedding, and everybody was in a party mood.

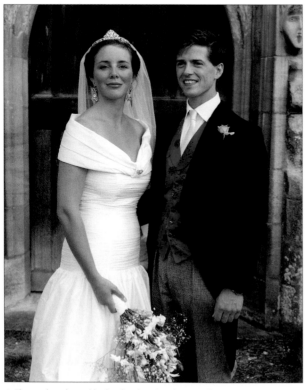

▲ The newlyweds outside the church, using the attractive stone archway and old wooden door as a background.

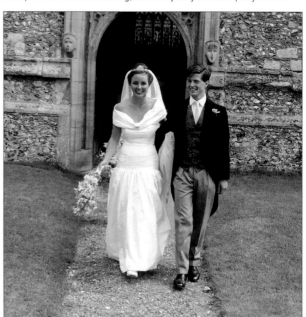

▲ All smiles and no trace of tension left as the newlyweds leave the church and face the assembled crowd of well-wishers.

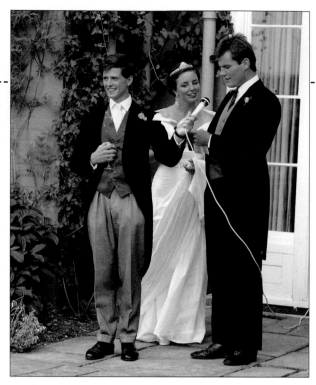

▲ At the reception, where the groom happily takes on the role of a microphone stand in order to help the best man through his speech.

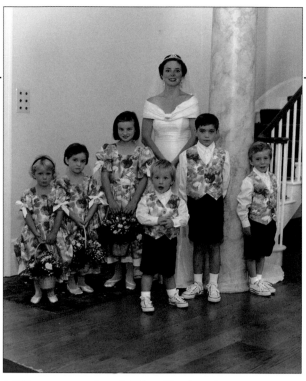

▲ Children were very much a part of this wedding day, and here the bride poses for a rare formal shot with her troop of colourfully clad bridesmaids and pageboys.

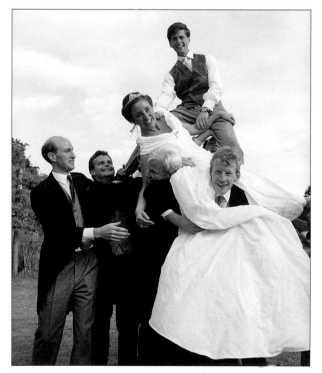

▲ Just for contrast, the bride and groom are hoisted aloft as the party mood at the reception intensifies.

▲ Some coverage of the reception was also shot in black and white. A nice touch, and very useful when you want to crop something out of the image area, is to hold light from the enlarger away from the paper during printing to create a soft-edged vignette.

DIRECTORY OF PHOTOGRAPHERS

Jonathan Brooks
Portrait House
13 Portland Road
Aldridge
Walsall WS9 8NS
UK
Telephone: + 44 (1922) 56067
Fax: + 44 (1922) 58049

Photographs on pages 46-7, 48

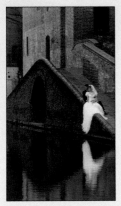

Richard Dawkins
133 Oxford Gardens
London W10 6NE
UK
All correspondence to:
161 Castle Street
Salisbury SP1 3TB
UK
Telephone: + 44 (1722) 335098

In a career stretching back to 1966 Richard Dawkins has worked with some of the best-known photographers in the world today. In his early career his work with John Cowan took him to Peru and Israel photographing for American *Vogue*, and Africa for *2001 – A Space Odyssey*. With Patrick Lichfield in 1969 through 1971 Richard's work included fashion shots for English *Vogue*, portraits of the British royal family at Windsor Castle and commissioned portraits of Princess Margaret. His interest in fashion photography was maintained with David Bailey through to the mid 1970s with shoots in Paris and Milan and various record covers, including the Rolling Stones, Cat Stevens, David Bowie, Elton John, and Alice Cooper. Richard turned freelance in 1974 and since then his photographic commissions have included international companies and magazines: Bowater, *Harper's Bazaar* (England and Germany), *Tatler*, *Vogue*, British Rail, Scholl, and *Country Life*. Also since turning freelance, Richard's wedding and portrait commissions have included private royal wedding parties at Claridges in 1981 and 1986, the royal wedding at Buckingham Palace in 1981, portraits of Sir Edward Heath, the Brunei royal family in Malaysia, Michael Jackson, and, in 10 trips to the Far East in 1993 and 1994, work with Diana Ross, Stevie Wonder, Elton John, MC Hammer, Bryan Adams, and Barrie White.

Photographs on pages 93, 114, 123

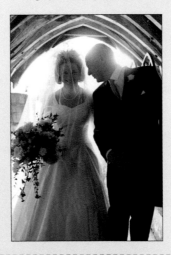

Philip D Durell
Aardvark Photography
3 Stockwell Terrace
London SW9 0QD
UK
Telephone: + 44 (171) 7358901

Philip started working as a freelance photographer about 12 years ago. His experience of wedding photography stretches back more than eight years and he finds that most of his commissions come about by way of word-of-mouth recommendations rather than advertising. Philip's style of photography is a mixture of formal and informal, and his preference is for location work rather than studio sessions.

Photographs on pages 74, 75, 76, 77, 90-1, 94-5, 126

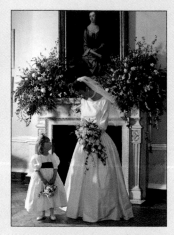

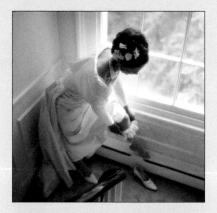

Trevor trained at the Ealing School of Photography before becoming an Associate of the British Institute of Professional Photography. He has been a professional photographer for more than 20 years, specializing in "people" photography for magazines and company reports. His wedding photography background now encompasses more than a thousand commissions in London and the South East. His style is essentially informal and he works in both colour and black and white. Trevor is the winner of two prestigious Kodak portrait awards.

Photographs on pages 21, 110-11, 113, 137

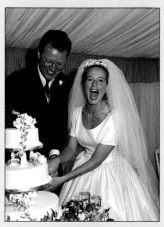

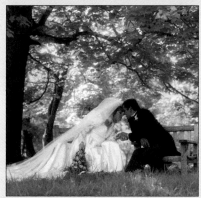

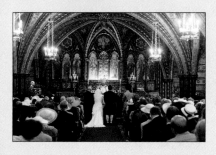

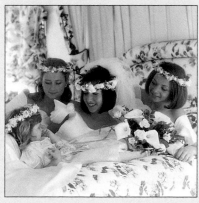

Desi Fontaine
60-62 Archway Street
Barnes
London SW13 0AR
UK
Telephone: + 44 (181) 8784348

Photographs on pages 28-9, 34, 35, 36, 37, 42, 43, 69, 84-5, 87

Trevor Godfree ABIPP
Trevor Godfree Associates – Photographers
Cherry Orchard Farmhouse
Hunt Street, West Farleigh
Maidstone
Kent ME15 0ND
UK
Telephone: + 44 (1622) 817835

Nigel Harper ABIPP AMPA CrGWP
21 George Road
Stokenchurch, High Wycombe
Buckinghamshire HP14 3RN
UK
Telephone: + 44 (1494) 483434

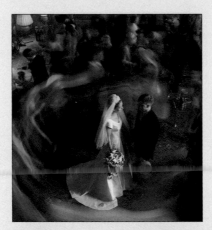 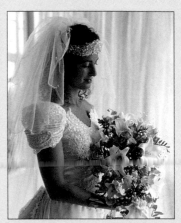

In 1988, after pursuing several different careers without any real satisfaction, Nigel decided to take a chance and turn his long-standing hobby into a, hopefully, enjoyable profession. He enrolled in two of Fuji's one-day seminars on wedding and portrait photography, and these were enough both to inspire him and to demonstrate his natural abilities in these photographic fields. His photographic business with studio is now based at his home, where his wife takes care of the administrative details leaving Nigel to concentrate on the photography and printing. Although his photographic career is only short, it has been punctuated by many awards: 1981 and 1982 winner of the Kodak Bride and Portrait Awards; more than 40 separate Fuji photographic awards, including 15 quarterly wins in the last two and half years; 1994 Fuji Wedding Photographer of the Year; and the Hargreaves trophy for the winning wedding portfolio in 1994. As well as running his thriving photographic business, Nigel also finds time to lecture on wedding photography in the UK and abroad.

Photographs on pages 31, 56-7, 60, 61, 66-7, 70, 78-9, 82-3, 86, 89, 100-1, 102-3, 105, 107, 108, 109, 121, 124-5, 132-3, 134-5, 136, 138, 139

 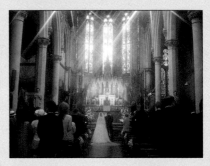

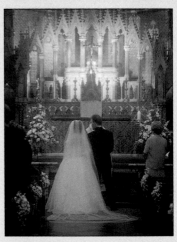

Gary Italiaander LBIPP ALCM(TD) PGCE
Harrods Portrait Studio
11 St George's Mews
London NW1 8XE
UK
Telephone: + 44 (171) 7229070
Fax: + 44 (181) 9075488

Highlights of Gary's career include: Kodak Gold Award winner; member of the Kodak Gold Circle; founder member of The Creative Portrait Circle; Chairman of The Creative Portrait Circle 1991-95; Member of the British Institute of Professional Photography; and Member of the Royal Photographic Society.

Photographs on pages 58, 62, 96, 97

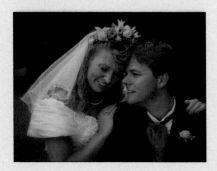

Majken Kruse LBIPP
The Coach House
East Compton
Shepton Mallet
Somerset BA4 4NR
UK
Telephone: + 44 (1749) 346901

Majken is a professional photographer with an active photographic practice specializing in weddings and portraiture. She started her working career in front of the camera as a model. At that time, photography was more of a hobby, albeit an important one. This experience, and a natural eye for photographic composition, led her to taking up photography professionally. Majken initially concentrated on children and general portraiture before widening her portfolio. She firmly believes that her experience in front of the camera helps her to relate to, and work effectively with, her subjects to achieve a natural look. Her creative talent, together with years of experience, are reflected in a very individual style.

Photographs on pages 8, 9, 16, 17, 18-9, 24, 26, 27, 92, 148-51

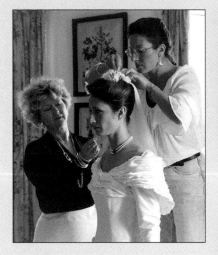

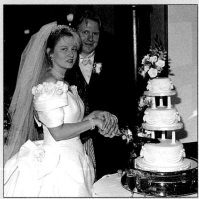

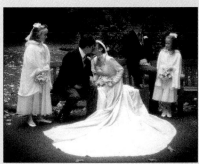

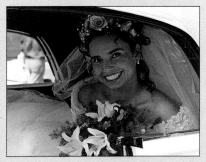

Hugh Nicholas
The Studio
Unit 7
The Leather Market
Weston Street
London SE1 3ER
UK
Telephone: + 44 (171) 4034935

Hugh has been a full-time photographer since 1982, but turned freelance only in 1989. He works principally in London, but sometimes in other parts of Europe as well. Although he recognizes that access to photography has never been easier, what with the advent of fully automatic cameras and high-street processing and printing, he is gratified to note that his services are in greater demand than ever before. Hugh's early training was in advertising photography and he feels that it was while working in that area that he learned that to be a success you have to offer the client something unique. He puts his own success as a wedding photographer down to his genuine and unfaltering enthusiasm, his preparedness to listen to his clients' requirements and concerns, and a calm, unflustered approach to the occasion.

Photographs on pages 38, 39, 40, 59, 98, 116-17, 126, 127, 152-3

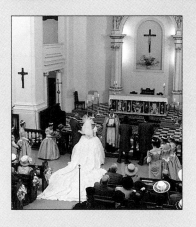

Mandi Robson LMPA
Morecambe Photographic Services
Plaza Studios, Queen Street
Morecambe LA4 5EL
UK
Telephone: + 44 (1524) 412 803
Fax: + 44 (1524) 832999

Photographs on pages 41, 99, 115, 128-9, 130, 131, 135

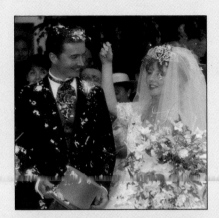

1970 Jos started his own business, combining photographic retailing with general photographic work. By 1980, however, he abandoned the retailing side completely to concentrate solely on undertaking commissioned photography. He is a three-time winner of the Camera d'Or. Throughout the years Jos has won many prestigious competitions, culminating in being judged Brides Photographer of the Year (England) in both 1992 and 1993. As well as running his business as a professional photographer, Jos has also been invited to lecture not only in his native Holland, but also in Belgium, Germany, England, Scotland, Norway, and Cyprus.

Photographs on pages 142-7

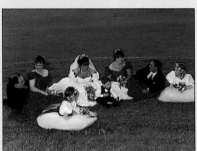

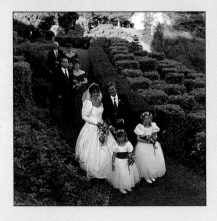

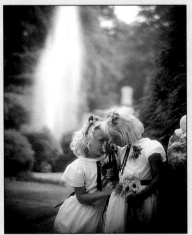

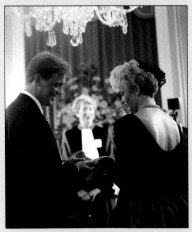

Jos Sprangers FBIPP
Dorpstraat 74-76
4851 CN Ulvenhout
The Netherlands
Telephone: + 31 (76) 613207
Fax: + 31 (76) 601844

As well as being a Fellow of the British Institute of Professional Photography, Jos is also a qualified member of the Dutch Institute of Professional Photography. In

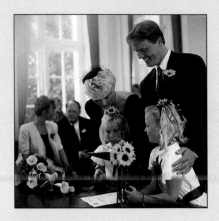

Peter Trenchard FBIPP
Image Store Ltd
The Studio, West Hill
St Helier
Jersey JE2 3HB
UK
Telephone: + 44 (1534) 69933
Fax: + 44 (1534) 89191

Over the years, Peter has gained an unrivalled reputation for fine portraiture. Apart from taking the official photographs of the Queen's visit to the island of Jersey and publishing the book *Expressions of Jersey*, Peter has won more than 20 major photographic awards, including five Kodak Gold Awards. As a professional photographer, he has developed a special talent for putting subjects at ease and he instinctively knows when to press the shutter to capture the best picture.

Photographs on pages 25, 50-1, 52, 53, 72-3

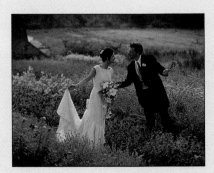

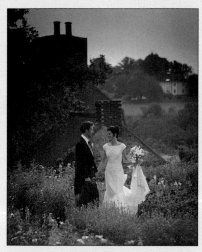

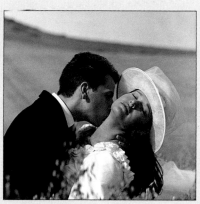

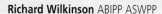

and his family from his photography and so he finally decided to turn his back on engineering. On average, Richard photographs about 30 weddings a year. Since he processes and prints all his own work, meets all his clients personally, and helps them make their final selection of photographs, he finds that this is more than enough to keep him busy throughout most of the year.

Photographs on pages 22-3, 55, 88

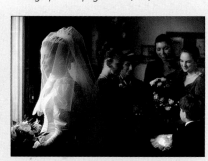

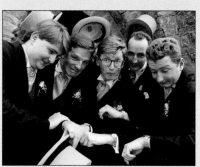

Van de Maele
Invalidenstraat 104
8310 Sint-Kruis
Belgium
Telephone: + 32 (50) 361889

Photographs on pages 1, 2, 7, 45

Richard Wilkinson ABIPP ASWPP
6 Glenfield Road
Brockham
Betchworth
Surrey RH3 7HP
UK
Telephone: + 44 (1737) 844736

Richard's first career was as a civil engineer and his interest in photography developed only about 10 years ago when he started working in the evenings part time for a firm of wedding photographers. It was here that Richard received his basic training, which, four years later, was to see him in business for himself. This was still only part time, however, photographing weddings on a Saturday and developing and printing his own work during the weekday evenings. From his successes it became apparent that he could earn enough to support himself

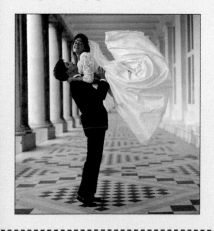

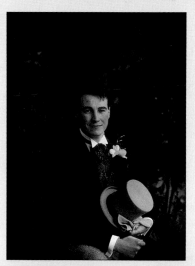

ACKNOWLEDGEMENTS

In large part, the production of this book was made possible only by the generosity of many of the wedding photographers who permitted their work to be published free of charge, and the publishers would like to acknowledge their most valuable contribution.

Similarly, the publishers would also like to thank all of the brides and grooms, best men and bridesmaids, pageboys and flowergirls, proud parents and guests who appear in the photographs included in this book. It is important to point out that all of the weddings featured on the preceding pages are "real" weddings. None of the photographs was staged with a view to publication, and we appreciate the glimpse the subjects have allowed us into their private lives.

The publishers would also like to thank the following individuals and organizations for their professional and technical services, in particular Koen de Witte of Fotoart, for organizing the contribution of the Dutch and Belgium photographers, Jos Sprangers, E.T. Archive, Richie Colour, and the equipment manufacturers whose cameras, lenses, and flash equipment appear at the beginning of the book.

All illustrations in this book were drawn by Madeleine Hardie.

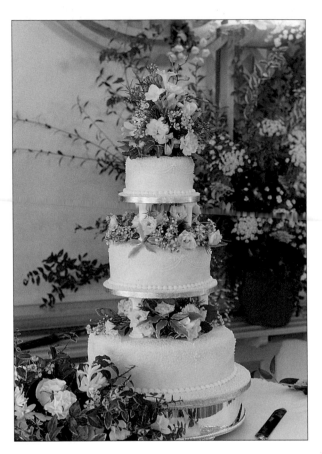